U0036529

INTRODUCTION TO

野生植物畫法

—描繪山慈姑—

赤　勘兵衛

發行／北星圖書事業股份有限公司

目錄

CONTENTS

Translation : Gavin Frew
Layout : Shintaro Nakamura
Photography : Yasuo Imai

第一章 [野外篇] 觀察與素描
Chapter One - Outdoor Section
Observation and Sketching

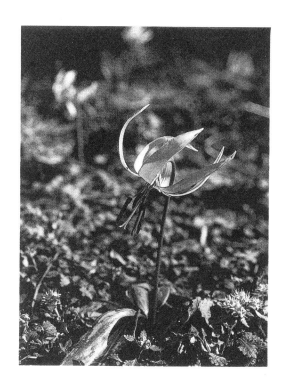

爲了幫助學習者瞭解戶外植物的繪畫方式。在此舉山慈姑做例子，有素描、觀察、照片、收集資料，樣品採集等。

　　在戶外觀察時，很容易被大自然的豐富景緻所吸引，忽略了觀察的重點，以致無功而返，需要觀察花的形狀，結構，葉子和莖之間的關係，在地面上的樣子，以及來訪的昆蟲種類等等，或許有必要花一整天的時間待在山慈姑叢中。

In order to understand the techniques involved in creating a botanical sketch of outdoor plants, let us take a look at the steps involved in producing a picture of that pretty spring flower, the Erythronium japonicum. These include sketching, observation, photography, the collection of data and the gathering of samples.

When making observations outdoors, the rich variety of nature offers a vast amount of information, but we must be careful not to allow ourselves to be overwhelmed by the mere quantity, otherwise it is easy to return home having missed some important point. What we need to study is the shape and construction of the flowers, the way in which the leaves grow out from the stem, the texture of the ground where they are growing and their relationship with various insects. To accomplish this might well entail a whole day spent observing the flowers.

環境的資料探集

◎山慈姑及環境自然環察

山慈姑是屬於春天易謝的植物,開在春天的森林裡,是一種美麗的花,觀察此圖的地方是在海拔900公尺高的林地上,地表上多石,附近開有白頭翁,森林裡有水楢(Quercus crispula),四手(Carpinus)等落葉樹木,山慈姑開花時期,葉子不會出現。因此地表顯得相當明亮。

The Erythronium japonicum is a beautiful ephemeral that grows on the floor of the forest in early spring. The flower in this picture was observed in a forest approximately 900 meters above sea level. The ground was very rocky and there was some Anemone raddeana blooming nearby. There were numerous deciduous trees, particularly Quercus crispula and Carpinus growing around the Erythronium japonicum, but these were not yet in leaf and the ground received a lot of light.

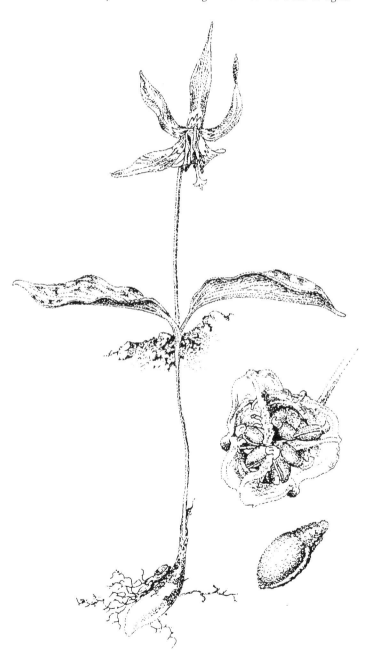

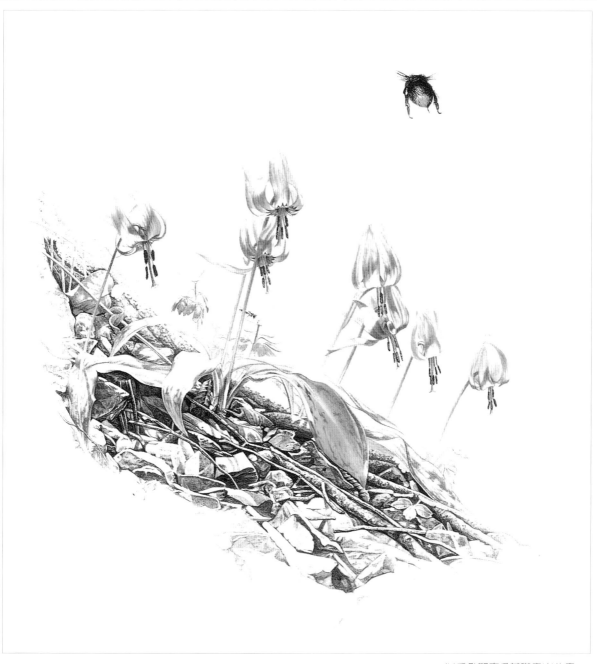

以戶外觀察爲基礎畫出此畫
The picture created based on outdoor observation.

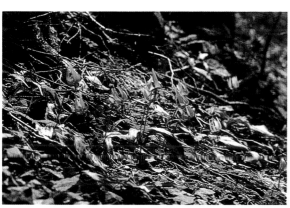

觀察的現場
The spot where the flower seen in the picture was observed.

素描

在户外描繪物體的細部並不是件容易的事，隨著風及陽光移動，花上之光及影子也受影響，若您喜歡陽光照射的景像，最好用相機照下來，從各個角度去觀察，決定目標後即可畫張素描。

It is very difficult to sketch the details of a subject when working outdoors. The flowers sway in the breeze, and the sun moves, altering the highlights and shadows. If you are particularly taken by the condition of the light, you should catch it in a photograph. Look at the subject from every angle and once you have decided on one that you like, draw a sketch.

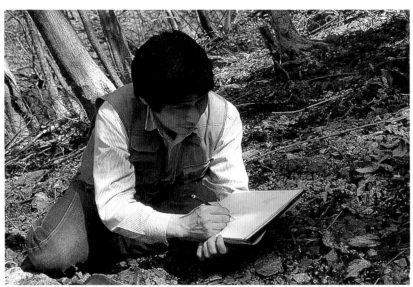

開始素描時，要先明確地決定角度視線。

Have a clear idea of the angle you are viewing from when making the sketch.

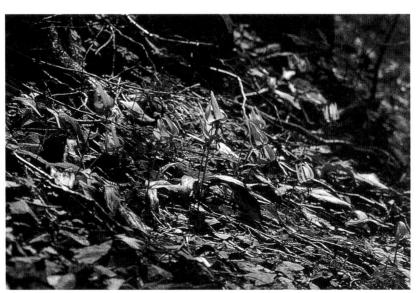

此現場的重點在於可見到美麗花姿的角度及早春的光線與斜面的表現。

The main points to watch in this sketch are to find the angle from which the flowers look most beautiful to express the spring sunshine and depict the slope where the flowers are growing.

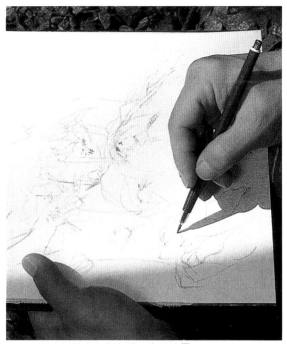

1 山慈姑成群地向旁生長，素描時最
好從低處觀察。

2 素描至中途，要停下來看整個構圖。

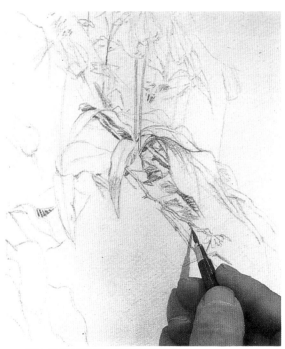

3 加上明暗的對比，強調光線和影子
的部分。

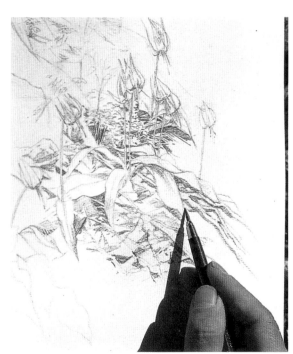

4 為達到此圖的效果，與周圍環境之
明暗關係也需特別留意。

素描

要注意光和影之表現以及陽光照射下柄和葉子的情形。

A pencil sketch. Attention should be paid to the interesting play of light and shadow, the way in which the light shines through the stem and leaves.

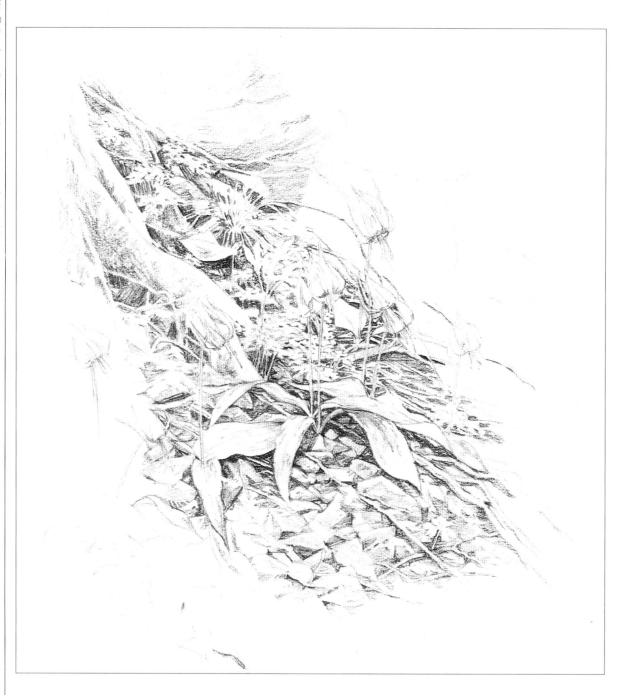

利用彩色鉛筆以修飾整體印象，實地繪畫會受制於時間，要留
意在短期間內完成，或利用照片完成。

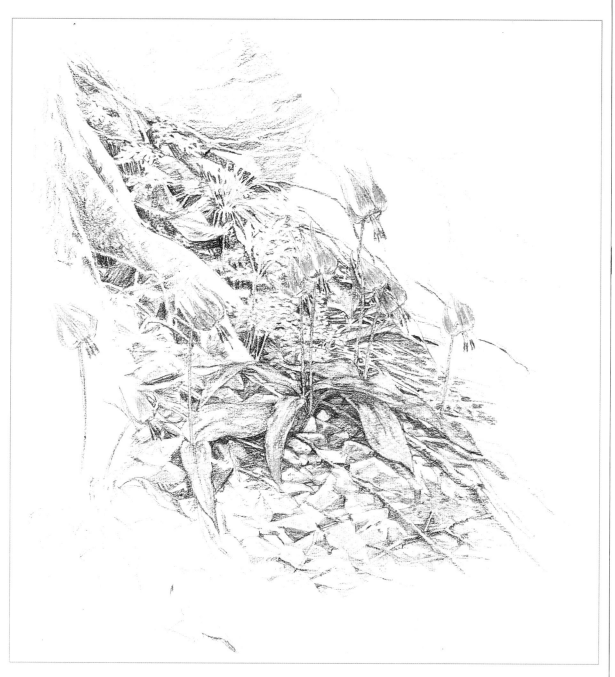

素描

◎細部素描

側面描繪花的時候，如果沒有考慮整個立體感，最後會變形，經由素描可瞭解花瓣，雄蕊及雌蕊的數目，花萼的形狀以及葉和柄連接的情況，最好是採用備忘錄式的素描法，除了顏色以外，其他發現到的事情也要記下來。

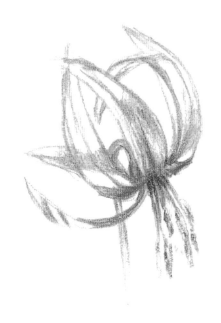

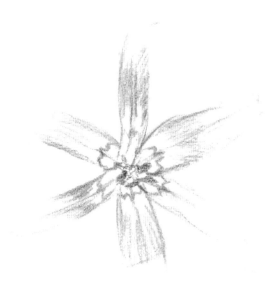

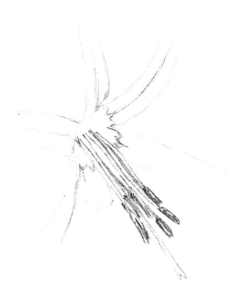

花蕊的樣子，花瓣及雄蕊雌蕊之平衡，形狀。

Details of the center of the flower. The balance and patterns of the petals, stamens, and pistils.

Sketching Details of the Subject

Even when you are drawing a side view of a flower, you must have a firm grasp of the overall shape, or the result is likely to look very strange. Your sketches should be used to help you see the number of petals, the number of stamens and pistils, the shape of the calyx and the way in which the leaves are connected to the stem and the best way to achieve this is to make a series of small "memo" sketches. Notes should also be attached to the sketches giving comments on the color and anything else you think may prove useful.

觀察花瓣與梗結合處之素描
A sketch which shows how the petals are connected to the center of the flower.

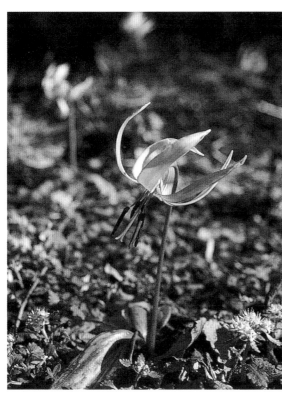

春日盛開的山慈姑
Details of the shape of the flowers and leaves

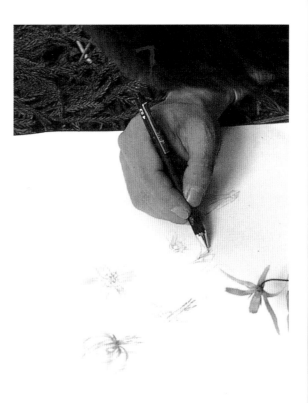

在現場觀察山慈姑並做細部素描
When the artist comes upon a specimen where it is growing, he makes a sketch of all the details

15

素描

◎素描白頭翁

白頭翁散落開在山慈姑周圍，依其吸收到的光量開放收縮，當我們在描繪花及葉子形狀之時，若有昆蟲來訪，也一併畫入。觀察時所看到的蟲，在描繪時要記住它各部位的顏色，回去之後對資料收集較有助益，昆蟲拜訪花兒的情況也很重要。

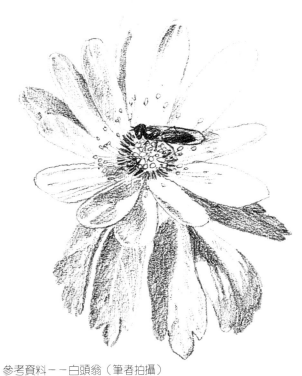

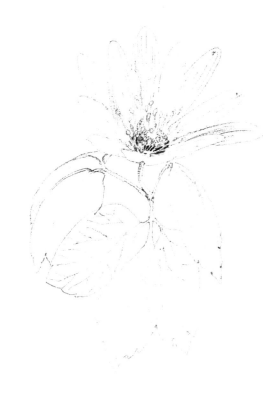

參考資料－－白頭翁（筆者拍攝）
A reference photograph of anemone raddeana (Photograph by the author).

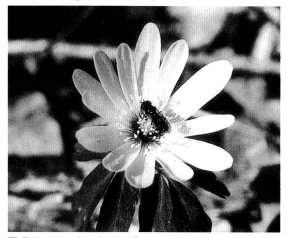

馬蠅的一種，它正在覓花粉。
A type of horsefly (Tabanus) is collecting the pollen

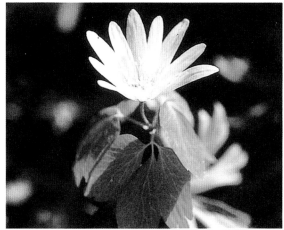

和素描同角度之照片
A photograph from the same angle as the sketch.

A sketch of an Anemone Raddeana.

Anemone raddeana were growing here and there among the Erythronium japonicum. This flower opens or closes according to the amount of light it receives. Draw sketches showing the shape of the flowers and leaves and if any insects come to the flowers while you are drawing them, you should make a sketch of these too.

When you sketch the insects you notice during your observations, you should add notes on the colors of their various parts as this will make it much easier to research them when you return home. It is also important to note how the insects settle on the flowers.

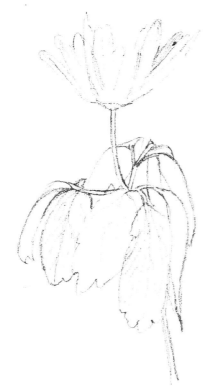

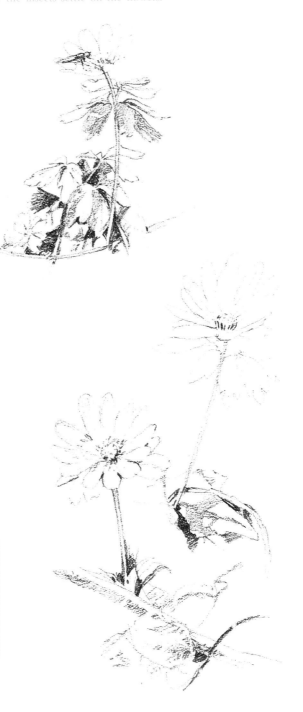

白頭翁依其吸收到的光量或開或謝，
素描部分花及葉子的形狀。

Anemone raddeana flowers open or close according to the amount of light they receive.

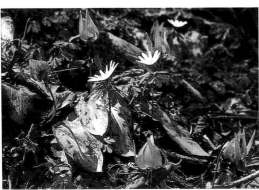

春天的陽光之下，山慈姑和白頭翁一
起綻放。

Anemone raddeana growing in the spring light among a group of Erythronium japonicum.

素描的畫具
Sketching Equipment

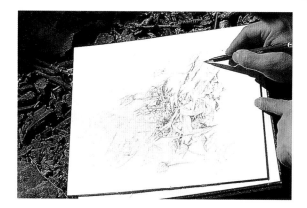

可更換的筆心及畫板
在戶外素描時省去削鉛筆的時間，筆心硬度以F～B為宜

Replaceable Leads and Holder :
This saves the trouble of sharpening a pencil and so are ideal for working outdoors.
F - B is a suitable hardness.

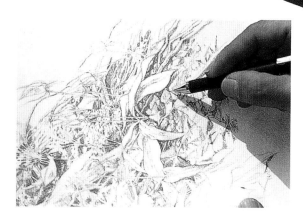

自動鉛筆
用在細節繪畫時，HB左右的硬度，最好用0.7，0.5，0.3mm的筆心。有色鉛筆20種顏色就夠了，戶外素描筆心的顏色與木頭顏色相近為佳

"Sharp" Pencil : This is necessary for adding fine details. The best best type to use is one that can take HB leads in 0.7, 0.5, and 0.3 mm. sizes.

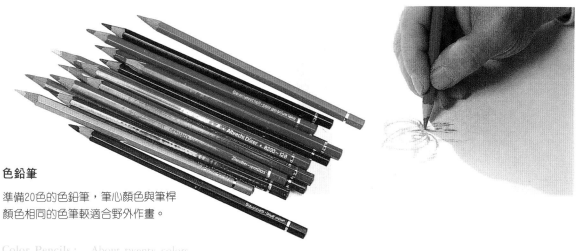

色鉛筆
準備20色的色鉛筆，筆心顏色與筆桿顏色相同的色筆較適合野外作畫。

Color Pencils : About twenty colors should be sufficient. The type in which the wood is colored to match the lead is the best for outdoors work.

素描簿
B5左右大小即可，紙質不要太粗糙為宜

Sketch pad : A B5 size is ideal. It is preferable that the paper texture is not too rough.

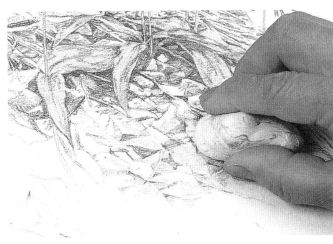

捏製橡皮擦
塗在線上修正時不會留下痕跡

Kneadable Eraser : This is useful as it can be pressed down on a line to adjust its tone and it does not create any waste.

削鉛筆機
調整替換筆心及色筆之尖度

Lead Sharpener : This is useful for sharpening replaceable leads and colored pencils.

觀察周圍環境

◎地面物之採集

繪畫的對象不僅限於植物，地面上之落葉，小樹枝及小石頭皆為觀察的對象，這些細微處使得植物以更優美的方式呈現，好好地觀察現場的情況，以採集繪畫所需之資料。

When you go out to gather information, you should not concentrate solely on the subject of the picture, but also note the fallen leaves, twigs and stones that cover the ground. These details serve to make the plant stand out in a more beautiful way. It is important to observe the overall details of the site where the flower is growing and store this information for use when creating the picture.

置於塑膠帶中帶回之採集物品
石頭上仍附有青苔

Samples can be collected and carried home in a plastic bag. Quantities of lichen are still attached to the small stones.

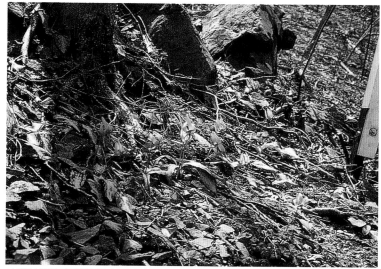

山慈姑開在有落葉及小石的地面上，也有去年四手之落葉，也有燈台樹的落葉。

The ground where the Erythronium japonicum grows is covered with fallen leaves and small stones. A lot of last year's Carpinus leaves can be seen. There are also some fallen Swida controversa leaves mixed in with them.

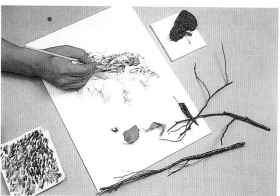

製作此畫時採集品發揮其功效

The items which were used as reference when making the picture.

繪畫地面的情形時，更能瞭解植物生長的環境。

By drawing the details of the ground where a flower grows we can obtain a deeper understanding of the kind of environment it prefers.

◎以落葉爲主題

Using Fallen Leaves
as a Motif

用Liquitex強調落葉的特色

A motif of fallen leaves that has been
colored using Liquitex

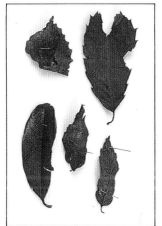

將收集到的落葉以大頭針固定,便形
成一幅美麗的圖畫,要仔細地描繪細
部之處,比起生動的花卉,葉子比較
容易畫,對於繪畫植物之入門者而言
是很合適的主題。

An interesting picture can be created if the
fallen leaves that you have collected are fixed
to a board with insect pins and used as a
motif. Care should be taken to illustrate all
the details of the leaves. Dead leaves are not
as difficult as live flowers and so they make
an ideal subject for people who are just
starting botanical art.

21

收集採花昆蟲

Collecting Insect
Pollinators

昆蟲活動之時間約在午後溫度較高之時，觀察時所看到的昆蟲，在素描時要記住它各部位的顏色，回去之後對資料收集必有相當的助益，能採集昆蟲的話就更好了，看看昆蟲是如何拜訪花兒。

Insects are most active in the afternoon when the temperatures are higher. When sketching the insects that visit the plant you are studying, make notes of the colors of the various parts in order to facilitate research when you return home. Collecting specimens of the insects is the best way to study them but do not forget to also study the way in which they interact with the plant.

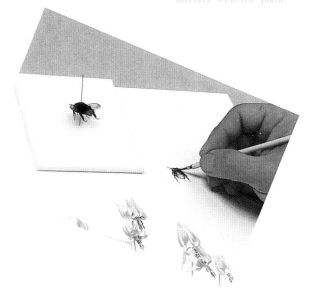

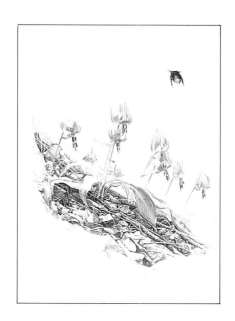

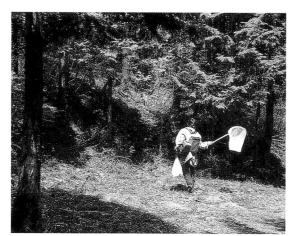

把素描簿，畫具，相機背在背後，將地面的採集物放入塑膠帶中，若能準備折疊式捕蟲網就更好了。

The sketchbook, drawing materials, camera are carried on the back. Plastic bags for collecting samples of the ground. All that is needed now is a folding insect net to produce a complete kit for outdoor research.

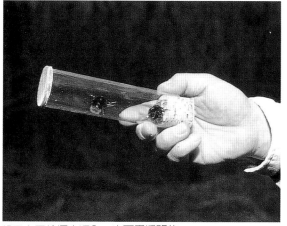

將昆蟲置於標本瓶內，也可用透明的薄膜代替。

A Bombus ignitus bee in a specimen bottle. A transparent film case can also be used for this purpose.

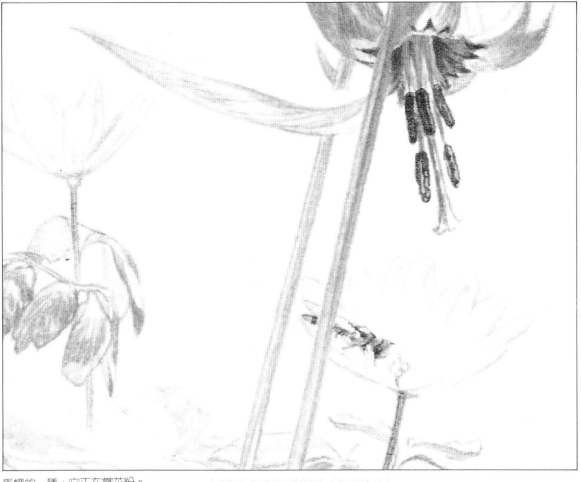

馬蠅的一種，它正在嘗花粉。

A type of horsefly. Habitant.... the shape of it where it landed on the flower to collect pollen

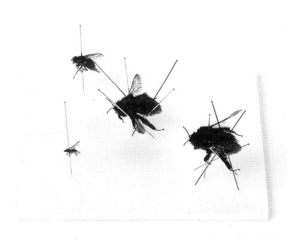

用大頭針把抓到的蜜蜂釘起來，趁蟲
子未乾掉以前把牠的翅膀張開。

The bee should be fixed with a pin and then its wings opened before it dries out.

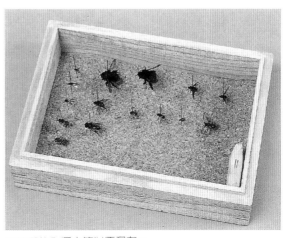

把牠們放入標本箱以便保存。

拍相片
Taking a Photograph

描繪植物生態畫時，相片是很重要的資料，用眼睛仔細觀察再素描會有遺漏之處，因此在複雜的環境下，拍下詳細的實況，多收集些資料照片，站在保護生態的立場上，我想用整體素描或照片的方式收集資料的情況會越來越多。

拍照時用單眼自動調節反光式照相機較方便。

An auto-focus single lens reflex camera is ideal for taking reference photographs.

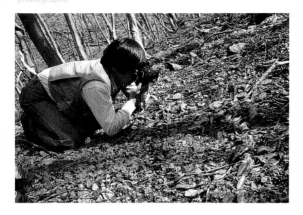

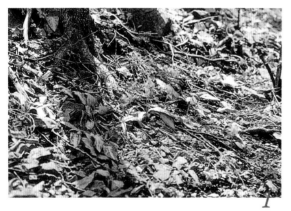

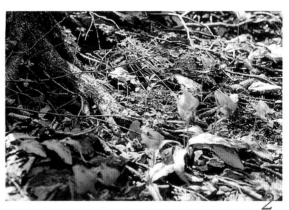

1 小群落的整體
2 樹根的上方
3 地面的情況，也可看到白頭翁的樹葉

1 An overall view of the grouping of the flowers
2 A detail of a tree root
3 A close-up of the ground. An Anemone raddeana leaf may be seen.

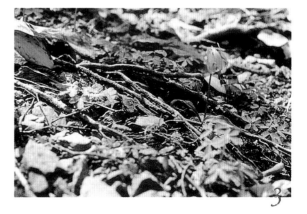

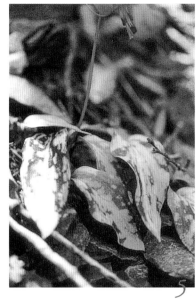

Photographs are a very valuable source of data for producing botanical art. Although you may intend to create a comprehensive sketch of the subject, there is always something that is missed. When working on a complicated environment it is good to take photographs of all the details and create a complete photographic reference. We all have a common duty to protect the environment and therefore in the future we will have to rely more and more on overall sketches and photographs as the sole reference for our sketches.

<div style="text-align:right">野外篇—觀察與素描● Outdoor Section - Observation and Sketching</div>

4 近距離的地面情況還有山慈姑及
　四手的枯葉
5 山慈姑葉子的特寫
4 The interest in the tree with Erythronium japonicum in the soil - bulbils becoming which may also be observed.
5 A close-up of the Erythronium japonicum leaves in the foreground.

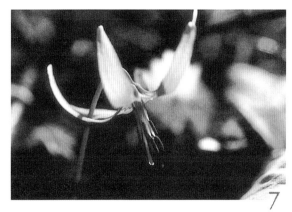

6 地面的特寫，看得到白頭翁的葉子
7 山慈姑的特寫
8 此處山慈姑和白頭翁開在一起

25

第二章 本畫製作
［室內編］

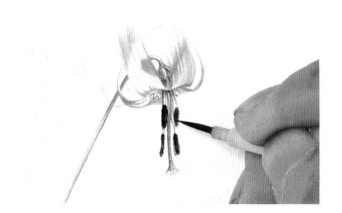

以戶外的素描及照片，收集品爲資料，開始製作本畫－
－山慈姑，同時也加入些白頭翁，爲表現出山慈姑在大自然
中生氣蓬勃的樣子，也要描繪出春天的陽光及地面的情況和
來訪的昆蟲。

Here we will produce a picture of a Erythronium japonicum using the
outdoor sketches, photographs and materials that were gathered on
location. Some Anemone Raddeana have been added to the group of
Erythronium japonicum. In order to recreate the freshness of the
Erythronium japonicum in nature we need to express the spring sunshine,
the details of the ground and any insects we observed visiting the flower.

製作本畫的畫材
Equipment for Creating
the Finished Picture

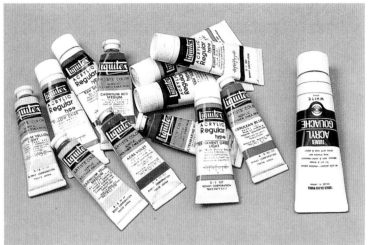

顏料
色彩以丙烯系(Liquitex)為主

Paints : Transparent acrylic paints (Liquitex) are the main paints used for coloring the picture.

畫筆
由於需細心地描繪上色，選擇黑體字
0號1號2號的細筆為宜。

Brushes : The color is built up using numerous fine strokes so fine brushes with rough tips in the no. 0, no. 1, and no. 2 range are best.

調色盤
陶器以白皿為宜。
Palette : A white china dish is useful.

洗筆器
具安定性且都以磁器為宜。
Brush Cleaner : A largish, stable, china container is ideal.

紙

好的水彩畫紙爲宜，繪畫時將之置於
畫板上比較不會弄皺

Paper ： Fine watercolor paper is
best and should be affixed to a
board to prevent it from wrinkling
when the paint is applied

橡皮擦

修正畫稿及描繪的修改時，捏製的橡
皮擦或一般的擦子皆可

Eraser ： Both kneadable and
ordinary erasers are used for
correcting the rough sketch and for
neatening up the tracing.

衛生紙

吸取畫筆上多餘的顏料

Tissue Paper ： This is useful for
soaking up any excess paint on the
brush.

鉛筆

H～B之粗細筆心，在臨摹畫稿時使用

Pencil ： A thick and a thin pencil
in the H - B range are used for the
rough sketch and tracing.

描圖紙

將底稿臨摹到本畫之時會用到。

Tracing Paper ： This is needed for
transferring the rough sketch to the
paper for the finished picture.

製作底稿
Making a Rough Sketch

回到室內，觀察收集到的資料，從拍攝的相片，和整體素描中，開始畫自己在大自然中感受到的野生植物，戶外的感受會隨著時間淡忘，趁還有印象時把底稿畫下來，或許看著照片或素描，構圖會有些修正，只要不過分不自然即可，將收集到的資料和照片及部分素描整理起來以便日後查閱。

◎在戶外收集的資料
The materials collected on location.

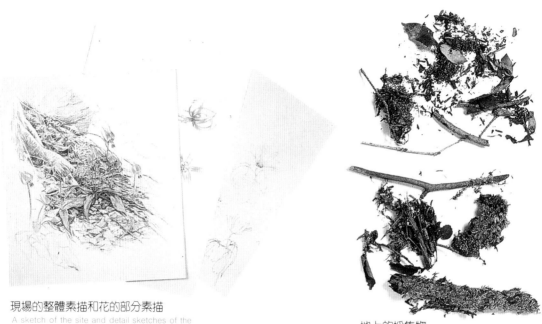

現場的整體素描和花的部分素描
A sketch of the site and detail sketches of the flower.

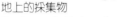

地上的採集物
Specimens of objects on the ground.

不同角度所攝的照片
Photographs from various angles.

蜜蜂的標本
A specimen of a Bombus ignitus bee.

After you return home, you should study the materials you collected, the photographs and the overall sketch then, when you have decided on the area that appeals to you most, it is time to start on the drawing. The impression you received when you were actually at the site will dim with time so it is a good idea to work on the rough sketch while it is still fresh in your mind. You can study the photographs and sketches and maybe even change the composition a little to create a better result, but be careful not to make it appear unnatural. The materials you collected, the photographs and the detail sketches should be arranged so you can find them easily when you need them.

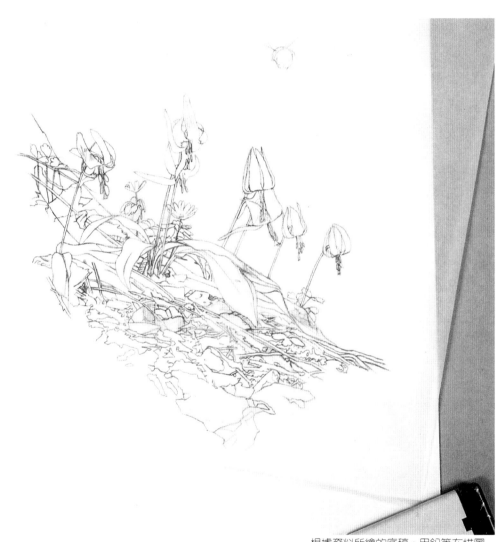

根據資料所繪的底稿，用鉛筆在描圖紙上小心地畫下來。

A rough sketch made from the materials collected on location. The shape should be drawn with a pencil thin lines on tracing paper.

臨摹底稿
Transferring the Rough Sketch

一但決定了臨摹的畫面，將本畫的紙放在底稿的上面，固定住使之不移動，再插入複寫紙，把底稿的線用自動鉛筆(0.3mm，2H)小心地描下來。

Once the design has been positioned to your liking, fasten the top of the sketch to the drawing paper with tape to ensure that it does not move. Placing a sheet of transfer paper between the two, go over the lines of the sketch carefully using a Sharp Pencil (0.3 mm, 2H).

◎複寫紙之製作
Making Transfer Paper

用鉛筆塗在描圖紙上即可容易地做出把底稿複寫到畫紙上之複寫紙使用H～HB之鉛筆避免上色後留下線條。

Transfer paper to trace the sketch onto the drawing paper can be made very simply by applying an even coating of pencil lead to a sheet of tracing paper. Use a pencil in the H–HB range to make sure the lines are not retained after the picture has been colored.

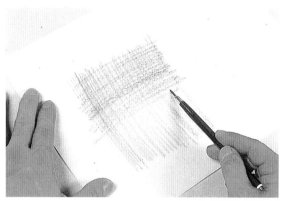

1 縱橫塗抹將描圖紙上的線條蓋住。

Rub the pencil over the tracing paper both vertically and horizontally to make sure the texture of the paper is completely filled with graphite.

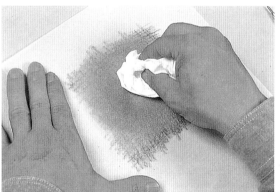

2 用衛生紙在紙上擦讓石墨把線條蓋住

Rub the surface of the graphite with a paper tissue to ensure that it is coated evenly.

3 完成的複寫紙

The completed transfer paper.

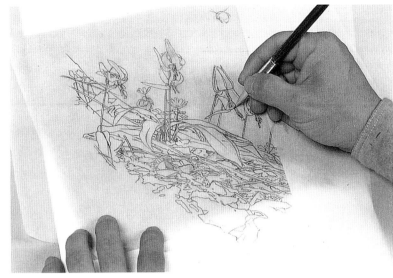

1

在底稿和本畫中間插入複寫紙，小心地描底稿的線

Place a sheet of transfer paper between the rough sketch and the drawing paper, then go over the lines of the sketch carefully again with a pencil.

2

偶爾確認描的情形

Check the lines occasionally while you work.

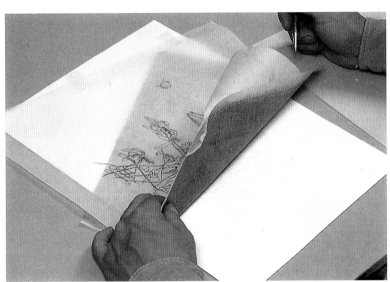

3

複寫後再輕輕地描一下輪廓即大功

The transfer work has been completed. All the outline appears as an overlapped line. Draw it again.

花的上色
Coloring the Flowers

◎稀釋顏料

顏料一旦稀釋後，使用衛生紙或布以控制畫筆上顏料的量，不是一次就上色，而是反覆地上色加深色度。

Diluting Paints
Once the paint has been mixed, control the amount you have on the brush using a paper tissue or cloth. The color should not be applied in a single coat, but in numerous thin coats built up until the desired tone has been achieved.

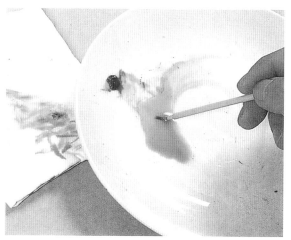

1 擠出來的花色先以水稀釋
The color of the flower is squeezed out of the tube and mixed with water.

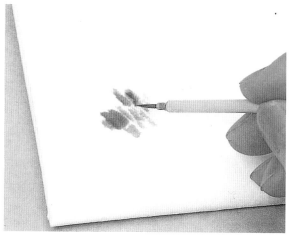

2 用4,5張衛生紙吸畫筆上過多的顏料
Four or five paper tissues are placed on top of each other then used to soak up the excess paint on the brush.

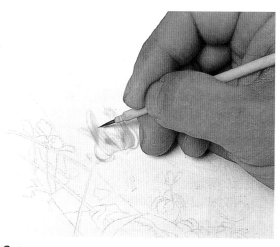

3 在淡色上用同樣的顏色加深濃度
Several thin coats of color are built up over each other to deepen the tone.

4 複製的鉛筆輪廓要是太濃留有痕跡，用插製橡皮擦輕輕擦掉再上色。
If the lines of the sketch are too dark they will remain visible through the paint so the kneadable eraser should be pressed down on the lines to lighten them before starting painting.

◎透光的山慈姑

當陽光照射在山慈姑上會產生透明的效果，花瓣和花柄處會重疊，這個地方顏色會比較濃，參考現場的素描及照片來表現顏色的深淺對比。

The sun shines through parts of the flower to create a translucent effect while in other places, the petals and stems overlay each other, blocking the light and creating a darker color. Use your sketches and photographs to recreate the contrasting depths of color created by backlighting.

5

花柄和花瓣的陰影處重覆上色，以提升濃度。

The areas of shadow caused by the the stems and petals is built up until the desired color is achieved.

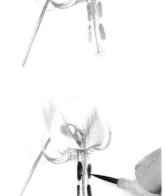

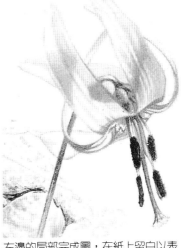

6

不透明的雄蕊用深的顏色

A dark color is used for the opaque stamen.

左邊的局部完成圖，在紙上留白以表示最亮透明之處。

A detail of the completed picture on the left. The white of the paper is left to express brightest most translucent areas.

7

使用同樣的顏色反覆上色顯出濃淡對比來表示反光。

The same color paint can be built up to show the contrasting depth created through the backlighting.

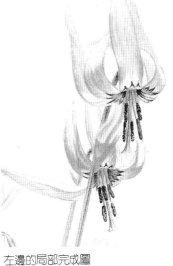

8

參考照片仔細地表現色彩濃淡的變化。

The variety in light and shade is built up carefully, using a photograph as reference.

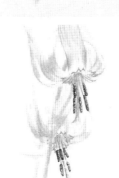

左邊的局部完成圖

A detail of the completed picture on the left.

35

葉子的上色
Coloring the Leaves

葉子和花一樣，需一片一片地上色，受太陽照射之處發亮的地方在紙上留白表示。

The leaves are carefully colored one by one in the same way as the flowers. The white of the paper is utilized to express the areas which reflect the light of the sun.

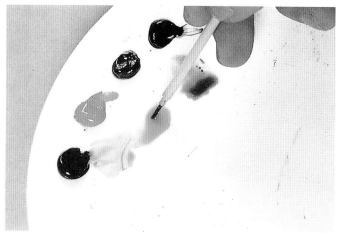

1 擠出葉子顏色
Squeeze out the color to be used for the leaves.

2 從陰影的地方開始上色
Start by coloring the areas that are in shadow.

3 用不一樣的顏色來表示斑點
左邊的局部完成圖
The characteristic spots are built up using a different color.

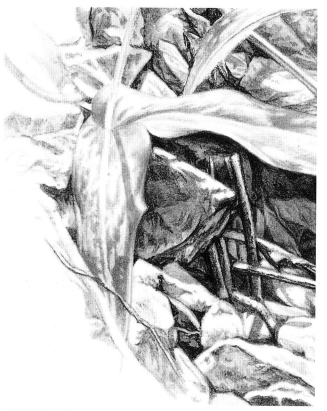

左邊部份完成圖。
A detail of the completed picture on the left.

4 塗上色度高的綠色，再塗上黃色顯
出葉子微妙的顏色
After colored with a high color saturated green, build up with yellow to create subtle the hues of the leaf.

5 仔細著斑點的顏色
Build up the spots carefully.

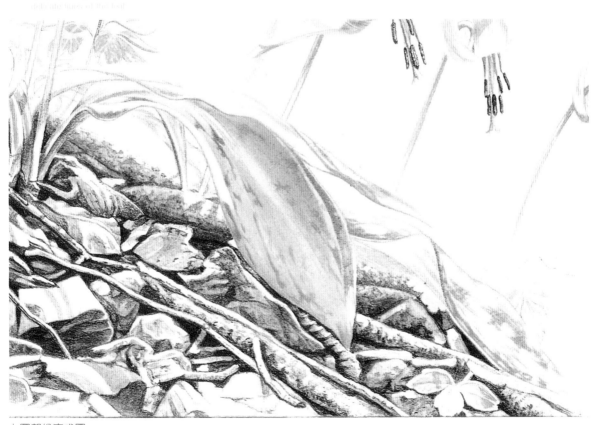

上圖部份完成圖。

白花的上色法
Coloring a White Flower

白色白頭翁與畫紙的白色融在一起，光的反射在葉子和花柄上色後再上些淡藍或紫色。

The white flower of the Anemone Raddeana tends to blend into the white of the paper therefore once the reflections on the leaves and stem have been applied, color the flowers using a very light blue or violet.

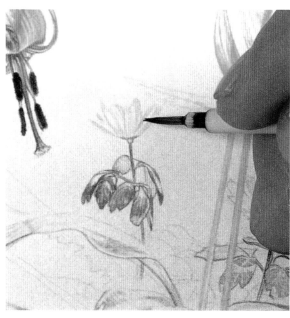

1 花瓣的顏色用淡藍或紫色。

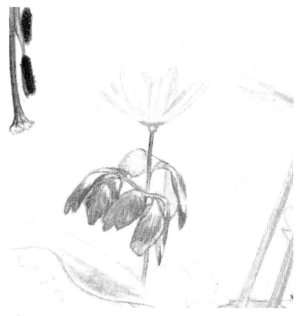

2 不破壞花的白色，著上淡淡的色彩

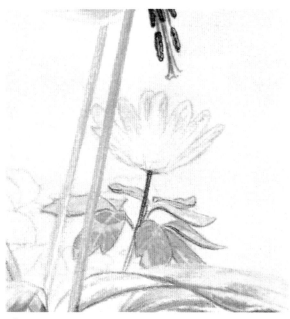

3 上色使花瓣的形狀很清楚

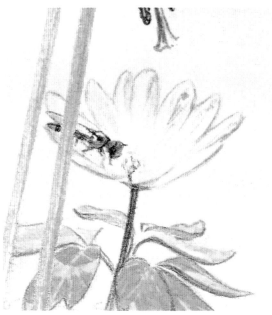

4 花蕊上色後，參考照片及標本，畫入馬蠅的一種昆蟲。

◎整體的製作過程　The Overall Painting Process.

1 花的部分一個個正確地上色
Each section of the flower is colored accurately.

2 把山慈姑的花全部上色
Color the whole flower of the Erythronium japonicum.

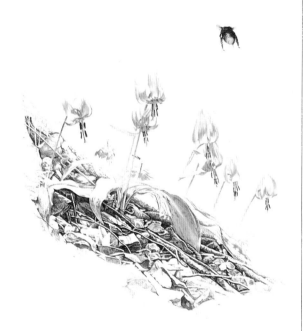

3 葉子上色完畢後可看出地面上的情況
Next color the leaves; you can then work out the situation of the above-ground area.

4 完成
The above-ground area takes shape.

第三章　描繪環境

繪畫的時候不能只畫主題植物，連周圍的地形和地面上
的落葉也要畫出來，雖然沒有畫出周圍的樹木但要表現出落
葉及植物自然生長的環境及其種類，表現出照在植物上的光
線就知道上面樹木樹葉的多寡，也得知當時的季節，試著
畫張與大自然緊密連接在一起的植物生態畫吧。

One should not concentrate solely on the subject flower but also show the
contours of the land, the fallen leaves around the plant and any other
plants that grow nearby. Even though you do not show the trees that
grow nearby, the fallen leaves show not only that the flower grows on the
forest floor but even what kind of trees the forest comprises of. The way
in which the light falls on the subject hints at the amount of foliage
overhead which allows us to guess what season it is. In this way, the vital
connection between plants and their surrounding environment can be
expressed in a single botanical painting.

山慈姑
Erythronium Japonicum

春日明媚的林地上開著山慈姑也可看到白頭翁及撞羽草，飛舞的蝴蝶為岐阜蝶 (Luhdorfia japonoca)。

An Erythronium japonicum blooming on the bright, spring forest floor. Anemone raddeana and Paris tetraphylla can also be seen. The butterfly in flight is a Lühdorfia japonica.

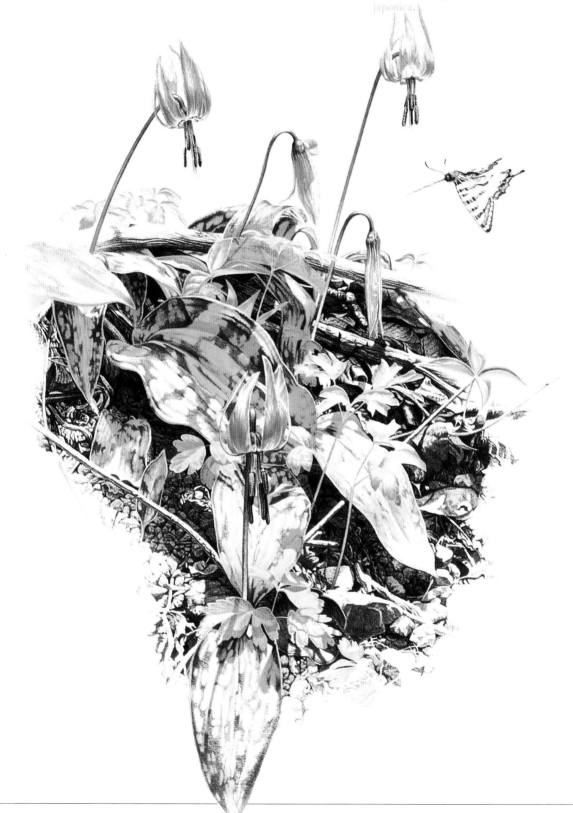

鹿蹄草

Pyrola Japonica

在雜木林的林地上，鹿蹄草長在樹木篩下來的光中，凸顯出小猶 (Querens serrata)，訪花昆蟲為黑丸花蜂 (Bombus ignitus bee)

The floor of a mixed forest. Pyrola japonica can be seen blooming in the light that comes down from the forest cover. Dead Querens serrata leaves stand out. Its pollinator is the Bombus ignitus bee.

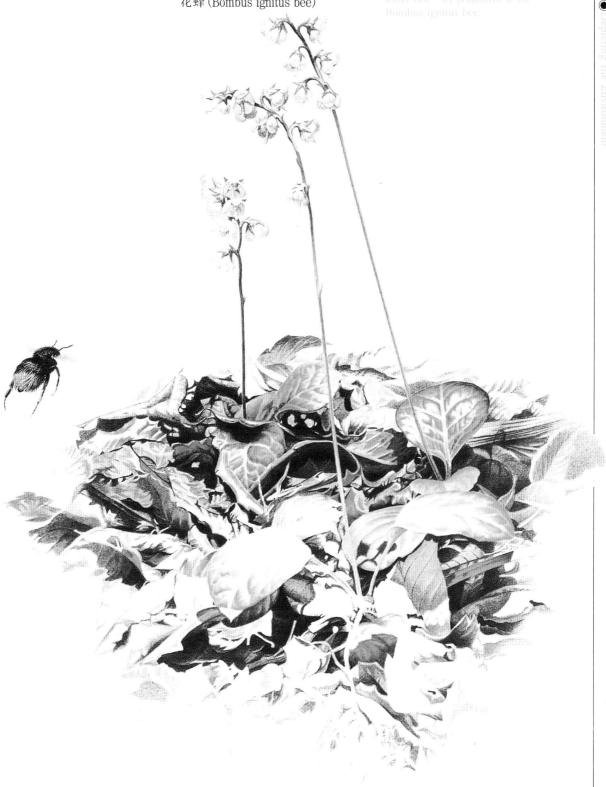

銀龍草
Monotropastrum Humile

梅雨時期開在林地上的銀龍草，訪花昆蟲為變色花蜂 (Bombus diversus bee)。

The Monotropastrum humile blooms on the floor of the forest during the rainy season. Its pollinator is the Bombus diversus bee.

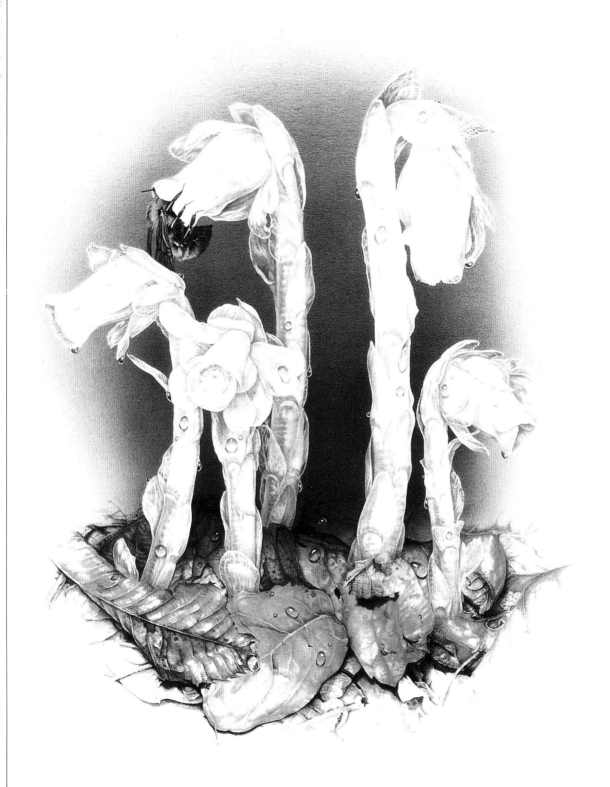

小百合
Disporum Smilacinum

小百合長在初夏森林的邊緣，訪花
昆蟲為三月姬花蜂（Andrena hebes
bee）

Disporum smilacinum which blooms
on the edge of the forest in early
summer. Its pollinator is the Andrena
hebes bee

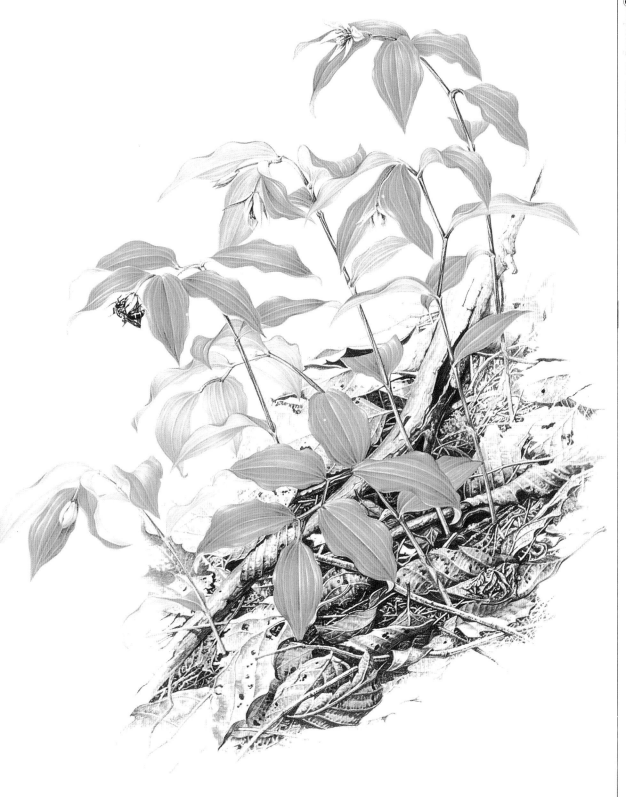

日本厚朴
Magnolia Bypoleuca

厚朴長在樹枝的前端，來採花粉的
昆蟲有Oxycetonia jucunda beetle及
變色花蟲

The flower which blooms on the tip
of the branches. The insects which
come to collect pollen include the
Oxycetonia jucunda beetle and the
Bombus diversus bees.

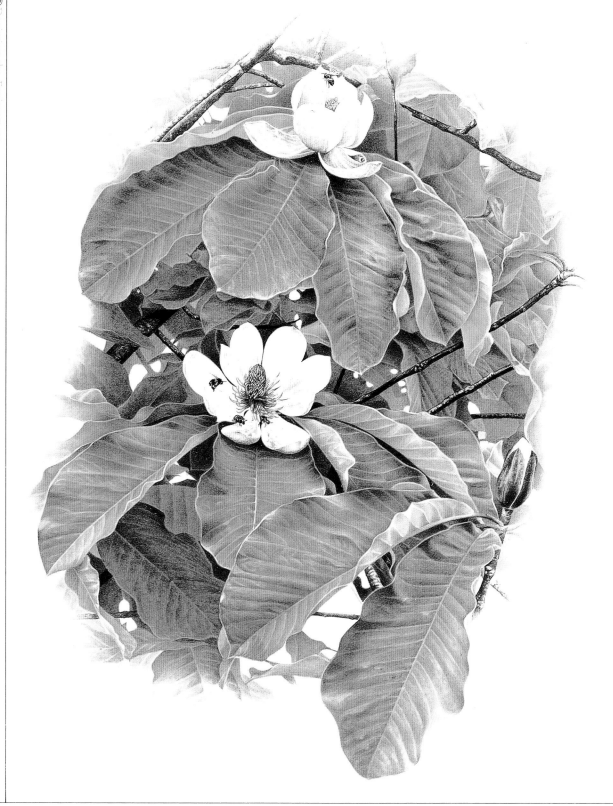

雙葉葵
Japonasarum Caudescens

雙葉葵長在六月陰暗的林地裡，形成一大片群落，在腳旁可看到小小的花。

The Japonasarum Caudescens blooms on the dark floor of the forest in June. It blooms in large clumps. The small flowers can be seen at one's feet.

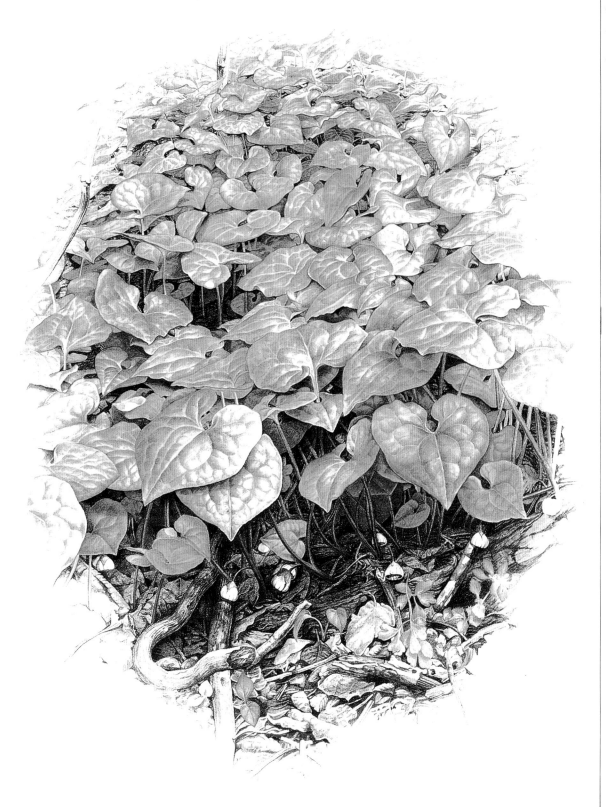

第四章 | 描繪生態

Chapter Four -
The Life of Plants

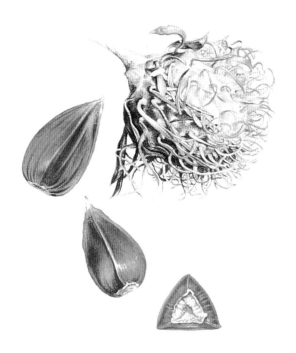

開花期的美麗姿態非常適合作植物繪畫之題材，本章我們將更進一步進入植物的自然生態領域，從發芽，結果中可看出植物生命力之神秘感，植物繪畫不僅捕捉美麗的花而已，表現植物各式各樣的生態也很重要。

The beautiful shape of a flower in bloom makes an eminently suitable subject for a botanical painting, but in this chapter we will go a step further and look at the plant's ecology in nature. The buds and fruit reach us of the mystery of the force of life. It is important when tackling botanical art not to become limited to the beauty of flowers but show all the various stages of the plant's ecology.

天南星
Arisaema Serratum

春天落葉中，天南星長出像蝮蛇般的芽兒，後面的樹幹是山櫻花，枯葉中也可看到杉的影子。

The Arisaema serratum grows among the fallen leaves in spring. It puts forth a bud which has markings similar to the pit viper. The tree trunk that can be seen in the background belongs to a mountain cherry. Dead cedar leaves can be seen among the other leaves on the ground.

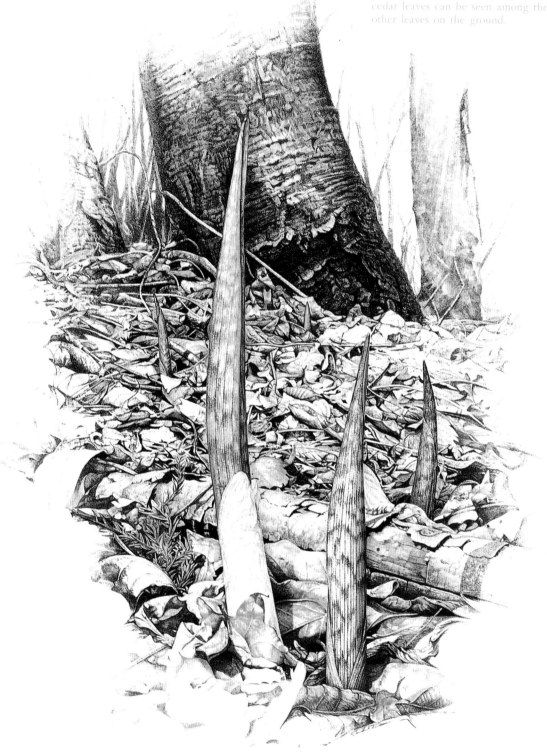

黑慈姑
Eleocharis Kuroguwai

稻子收成時，從稻中可看到黑慈姑
的影子，停在上面的昆蟲為秋茜
（Sympetrum frequens）

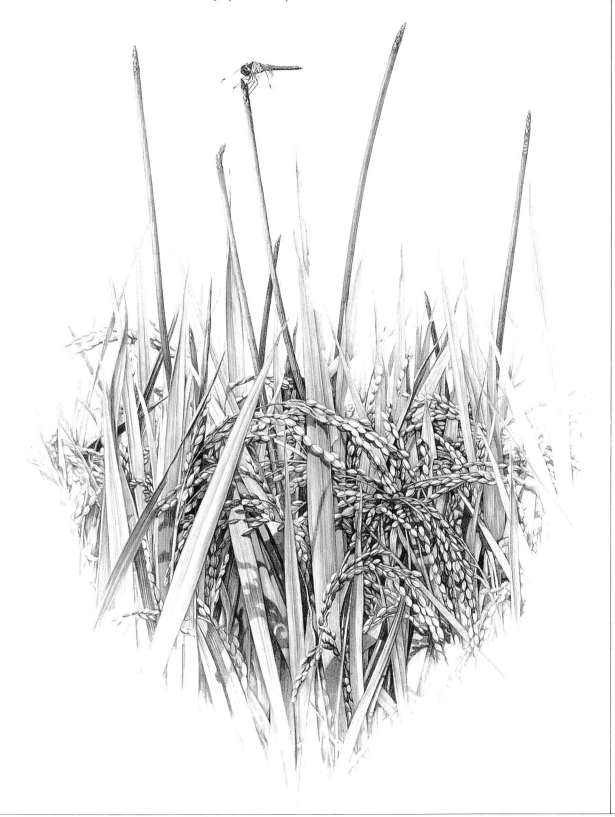

第五章 描繪授花粉者

Chapter Five
Drawing Pollinators

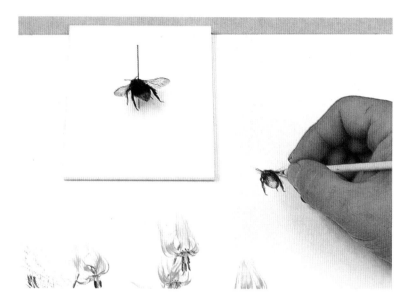

大部分的授粉者為蜂及馬蠅，此外蝴蝶和甲蟲也很重要，白眼鳥和鵯同樣也扮演著重要的授粉者角色，仔細觀察牠們和花接觸的方式，更能把生態畫表現得更好。

　　雖然是門專業的科學，但由此可知種子是藉由鳥類運送一事，將這情形畫在圖中更可以提高植物畫的水準。

The most common type of pollinators are bees and houseflies, but butterflies and Cetonia pilifera beetles also play their part. Pollinators are not limited to the insect world, however, and birds such as the white-eye and the bulbul play an important role. The contact of these pollinators should be studied carefully as their inclusion in a botanical picture will serve to make the subject come to life.

Although it is a rather specialist subject, it has been proved that birds and insects also play an important role in the transport of seeds. This process can be captured in a botanical painting, to create a beautiful work.

◎ 拜訪秋之麒麟草的昆蟲

Insects Gathering on a Solidago
Virgaurea - Asiatica

10月花開較少的期間，蟲兒們聚集在黃花上，蝶類有紋黃蝶，芋胥，紅小灰(Lycaena phlaeas daimio)，馬蠅類有Epistrophe balteata及花虻，蜂類為Campsomeris annulata species。

Insects gathering on the yellow flowers in October when there are not many other flowers. Among the butterflies one can see Parnara guttata, Colias erate poliographus, Vanessa cardini, and Lycaena phlaeas daimio. Among the horseflies, we see, Epistrophe balteata and Eristalomyia tenax while the bee is of the Campsomeris annulata species.

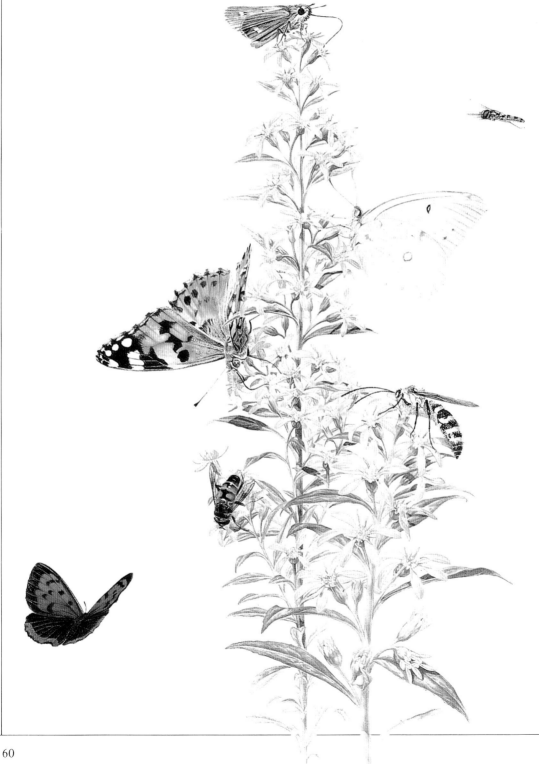

蝴蝶
Butterflies

蝴蝶停在花上的姿態，在繪畫時要留心取自然的角度，鳳蝶類停在花上時，前端的翅膀會有小顫動，請仔細觀察。

When depicting a butterfly on a flower you should experiment to find a natural-looking angle. When butterflies of the Papilionidae family settle, they move their front wings in short motions. Time spent studying these insects is time well spent.

● Parnara guttata 蝶
伸嘴吸蜜
Parnara guttata.
Extending its mouth to drink the nectar.

● 苧胥
不用前鼓，直接停在花上吸蜜
Vanessa cardui.
It is standing on a flower, without using its front legs, while it drinks the nectar.

● 紋黃蝶
留心停在花上的腳
Colias erate poliographus.
Attention should be paid to the way it holds its body when it settles/perches on a flower.

◎日本厚朴和大斑啄木鳥
A Great Spotted Woodpecker and
of the Magnolia hypoleuca

大斑啄木鳥正在吃落葉後日本厚朴留下來的果實，有些種子一
定要經過鳥類的消化器官才會發芽。

The great spotted woodpecker eats the fruit of the Magnolia hypoleuca
after the tree has shed its leaves. There are some seeds that do not
germinate without passing through a bird's digestive system.

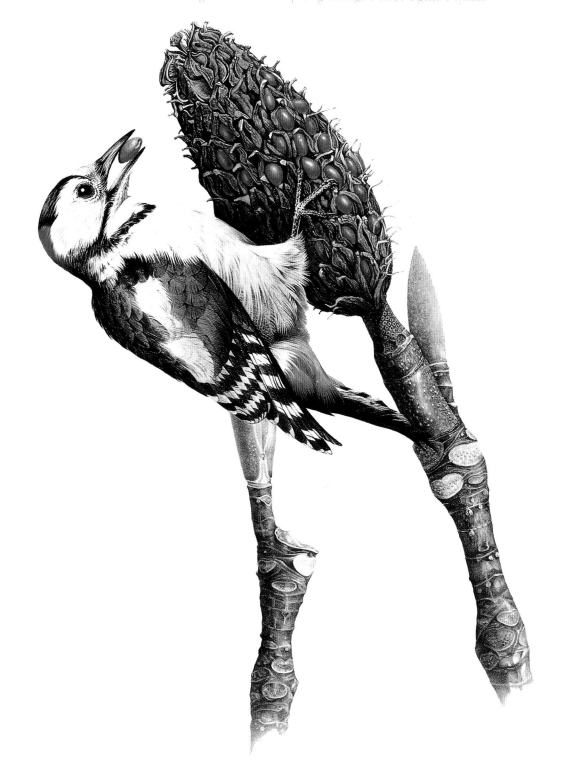

鳥－－大斑啄木鳥
A Great Spotted Woodpecker

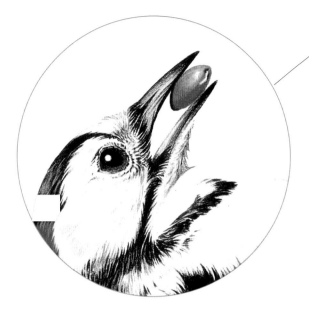

叼著種子的鳥嘴
The beak shown holding a seed

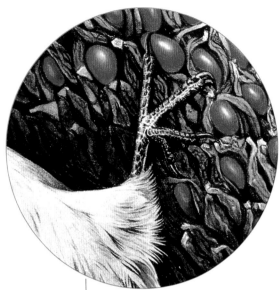

注意腳的姿勢
Note the shape of the foot grasping the stem

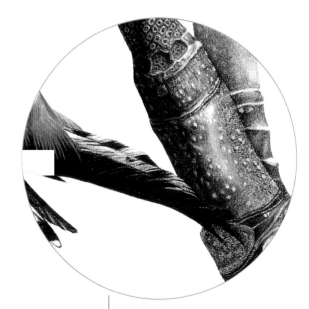

以尾扎支撐身體
It uses its tail to support its body.

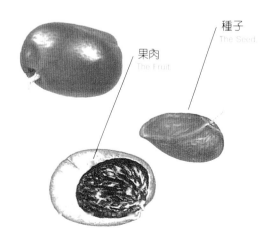

果肉
The Fruit

種子
The Seed

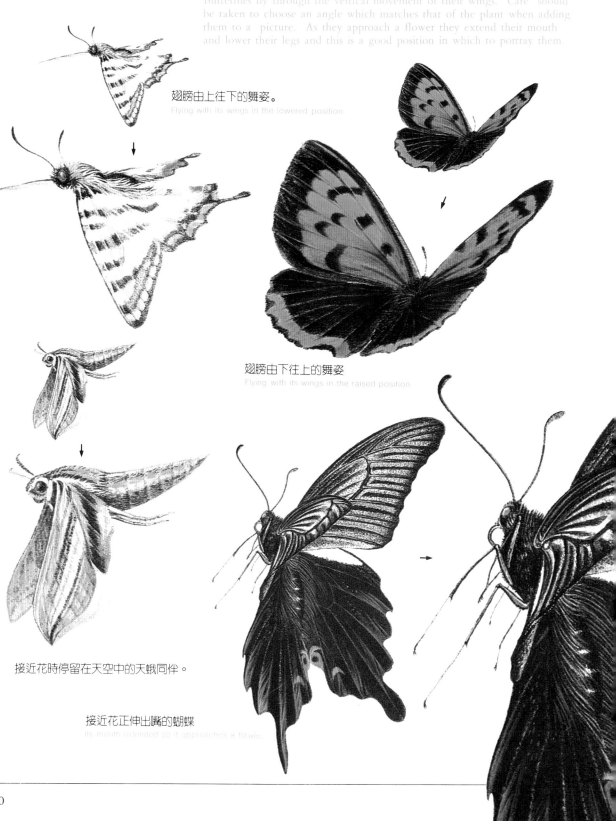

飛舞的昆蟲

Insects in Flight

◎蝴蝶 Butterflies

蝴蝶上下振翅飛翔,選擇配合植物的角度加以描繪下來,還有接近花時,伸嘴,停腳的姿態很值得描繪下來。

Butterflies fly through the vertical movement of their wings. Care should be taken to choose an angle which matches that of the plant when adding them to a picture. As they approach a flower they extend their mouth and lower their legs and this is a good position in which to portray them.

翅膀由上往下的舞姿。
Flying with its wings in the lowered position.

翅膀由下往上的舞姿
Flying with its wings in the raised position.

接近花時停留在天空中的天蛾同伴。

接近花正伸出嘴的蝴蝶
Its mouth extended as it approaches a flower.

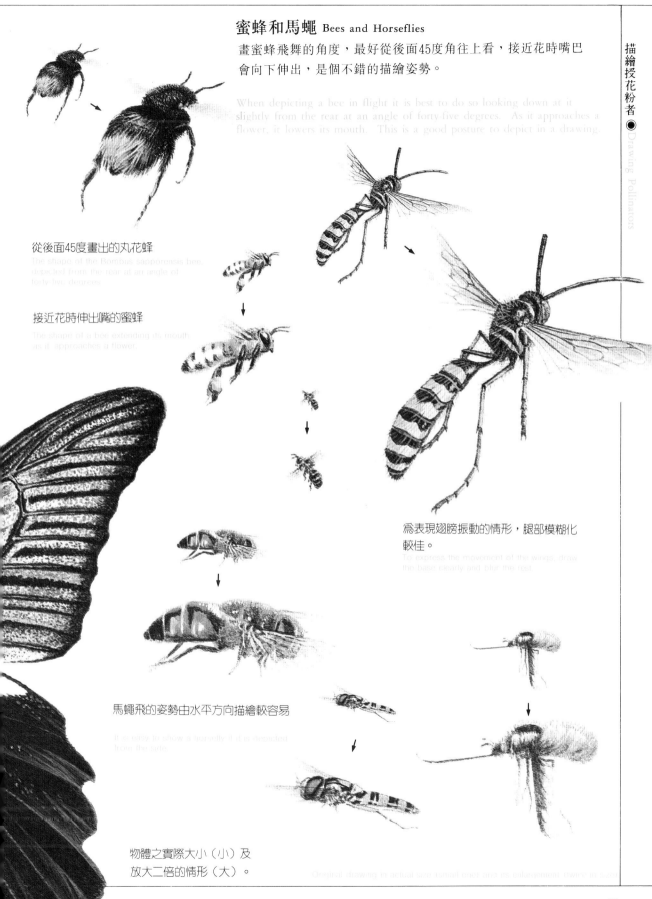

蜜蜂和馬蠅 Bees and Horseflies

畫蜜蜂飛舞的角度，最好從後面45度角往上看，接近花時嘴巴
會向下伸出，是個不錯的描繪姿勢。

When depicting a bee in flight it is best to do so looking down at it
slightly from the rear at an angle of forty-five degrees. As it approaches a
flower, it lowers its mouth. This is a good posture to depict in a drawing.

從後面45度畫出的丸花蜂
The shape of the Bombus sapporensis bee,
depicted from the rear at an angle of
forty-five degrees.

接近花時伸出嘴的蜜蜂
The shape of a bee extending its mouth
as it approaches a flower.

為表現翅膀振動的情形，腿部模糊化
較佳。
To express the movement of the wings, draw
the base clearly and blur the rest.

馬蠅飛的姿勢由水平方向描繪較容易
It is easy to draw a horsefly if it is depicted
from the side.

物體之實際大小（小）及
放大二倍的情形（大）。
Detailed drawing of actual size (small) over and its enlargement (twice its size).

71

第六章 描繪科學化

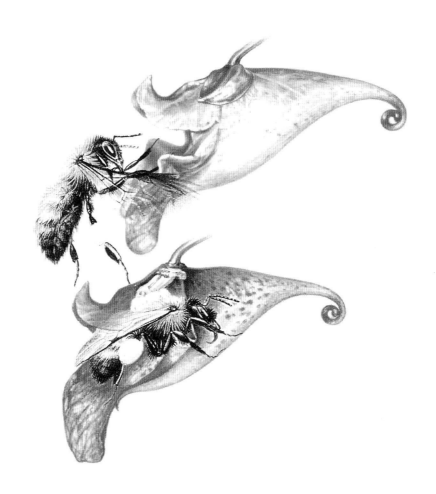

我們無法直接從大自然中觀察到植物的成長，如根的模樣，種子的結構等，具體地描繪成長的時間經過及地面上下的情況也是植物畫的表現之一，本章來看從大自然中可收集那些資料，並利用之繪圖。

The way a plant grows, the details of its roots or the construction of the seeds are all features of the plants life that we cannot observe directly in nature. The progress of a plant's growth over a period of time or the details of its shape both below and above ground are another field of expression within botanical art. In this chapter we will look at the information we can gain from nature and see how it can be arranged to create a single painting.

天南星的授粉
Pollination of Arisaema Serratum

天南星有不一樣的授粉方式,秋天成熟,結果,到春天發芽的情形都畫出來,訪花昆蟲為Mycetophilidae。

The Arisaema serratum has an unusual system of pollination. The picture shows both the fruit of autumn and the spring buds. The pollinator of this plant is a type of Mycetophilidae.

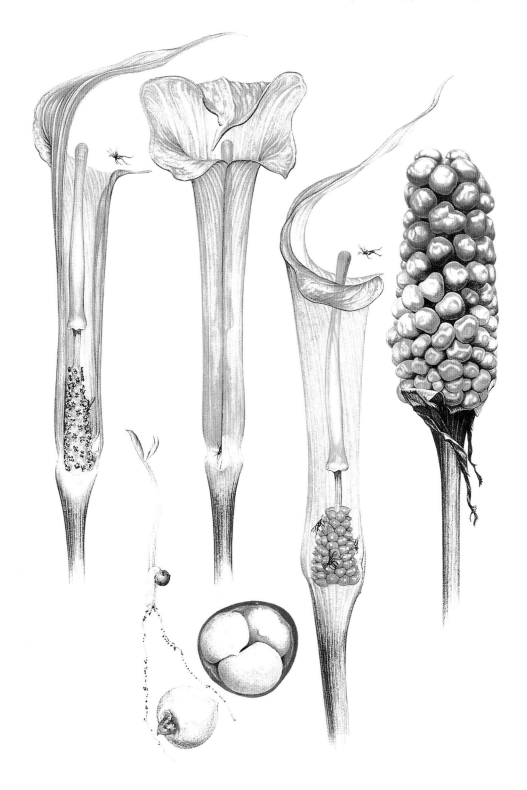

野鳳仙花之授粉

Pollination of the Impatiens Textori

拜訪野鳳仙花助其授粉的有大丸花蜂、蜜蜂、西洋蜜蜂及Macroglossum stellatarum。在此畫出授粉的過程。

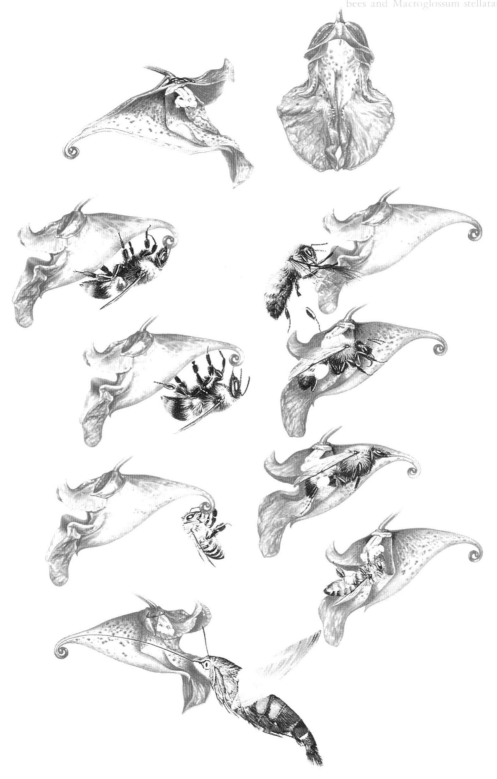

猩猩裙
Heloniopsis Japonica

猩猩裙地面上及地面下（根莖）與根的樣子，圖為再生繁殖體，花和傳播者的放大。

This picture shows the entire Heloniopsis japonica plant, including both the part above ground and that below (the rhizome and roots). An enlargement of the reproductive system. An enlargement of the flower and a pollinator.

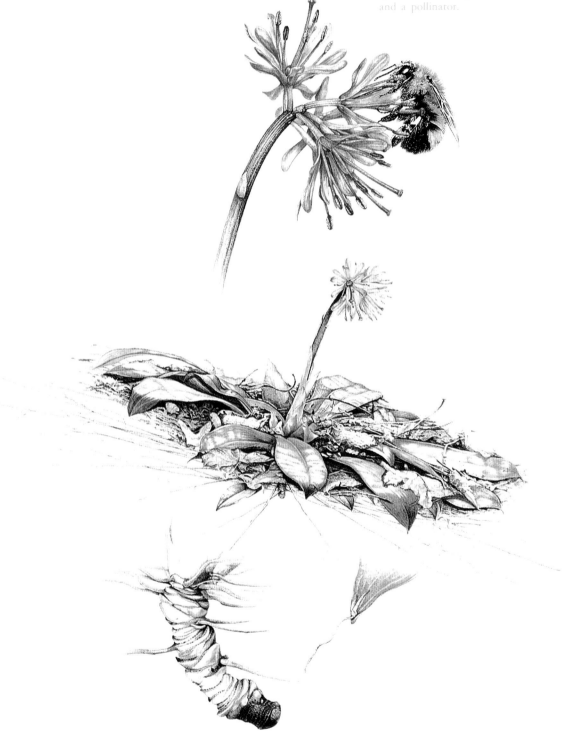

猩猩裙
Heloniopsis Japonica

猩猩裙的發芽及種子的形成，按著時間不同繪出種子的變化，有擴大版及局部擴大版。

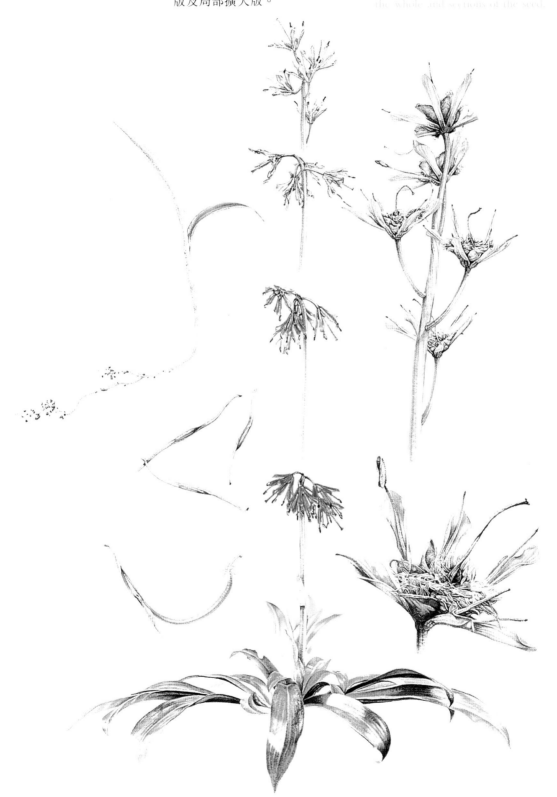

小百合
Disporum Smilacinum

10月小百合地面上和地面下的情形，畫出地下莖，也畫出側面圖，要留心毛根部土的畫法。

The entire Disporum smilacinum plant in October. The rhizome has been included. A cross-section of the seed has been added. Care should be taken when portraying the hair roots and soil.

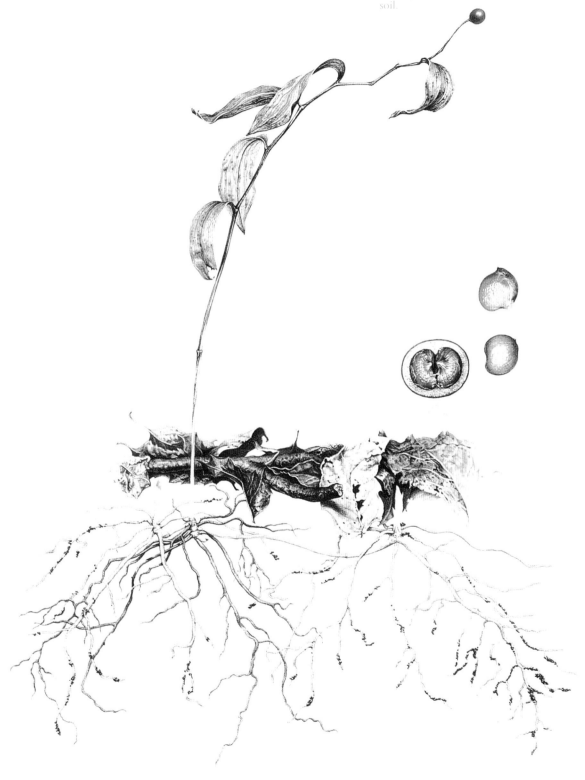

小百合

Disporum Smilacinum

四月末，小百合的一個體，要注意
分開地上和地下之地面處理方式。

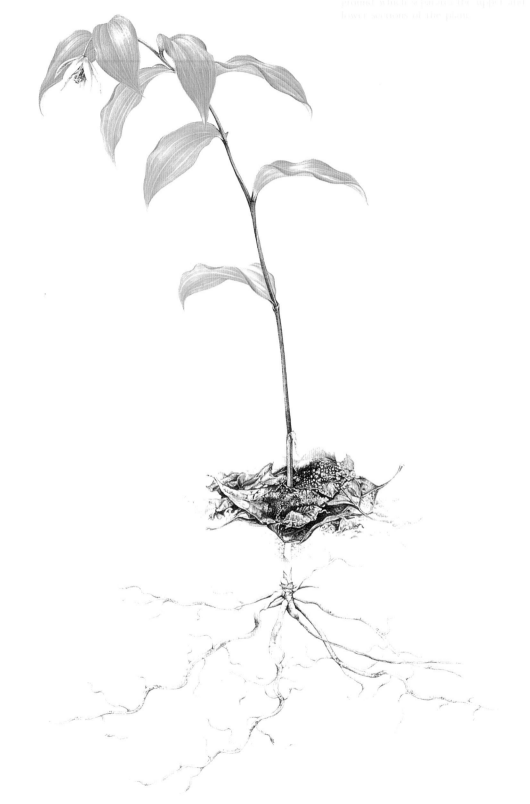

雌蛭木林
A Kandelia Candel Grove

厭氣中的美洲紅樹林

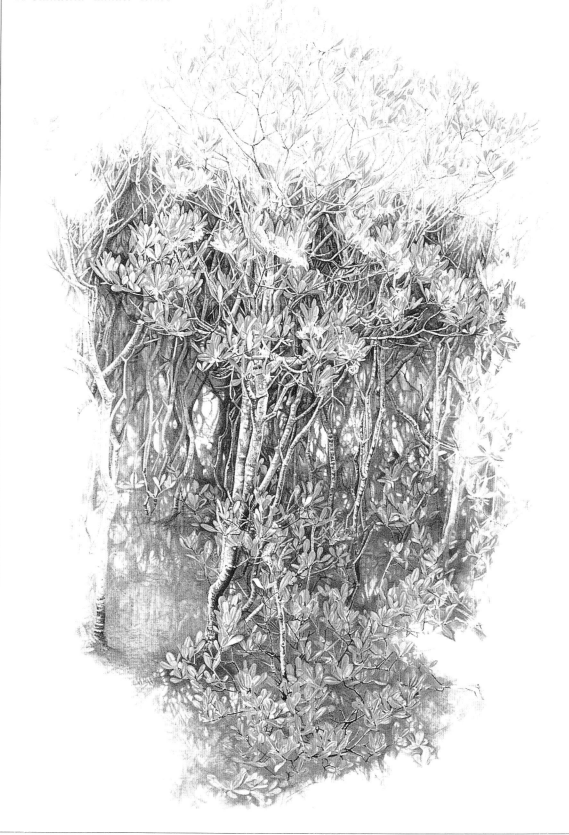

雌蛭木之花

開花期來訪的Lampsomeri's annulata
bee及開花期的樣子。

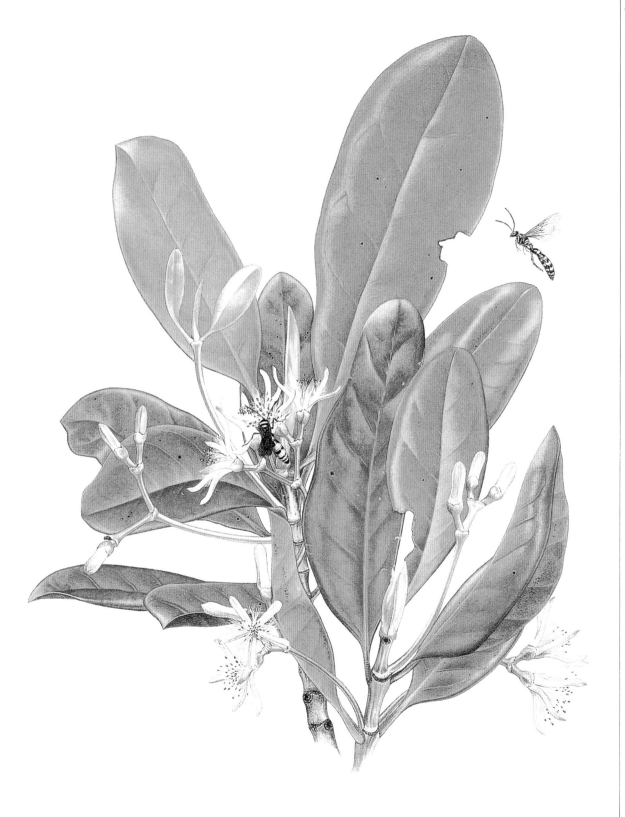

雌蛭木的花芽及種子

The Buds and Seeds
of the Kandelia Candel

花芽的成長到胎生種子發芽為止。 The growth of the buds to the production of a viviparous seed.

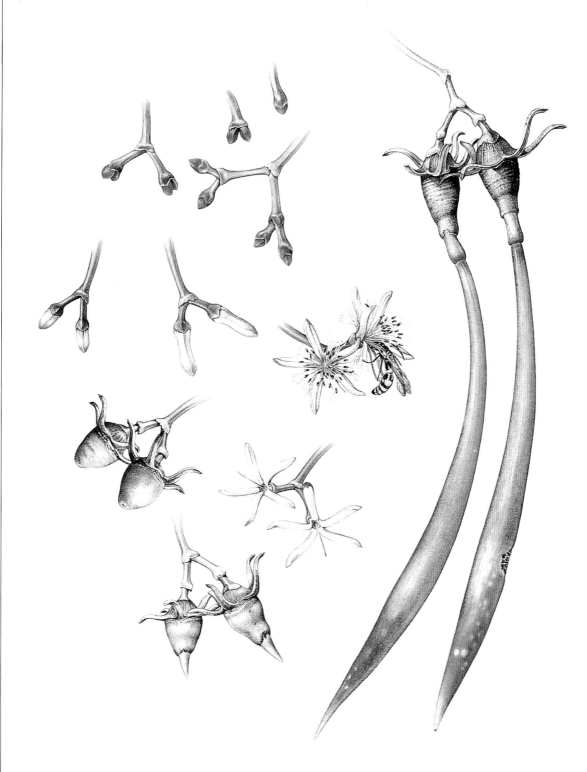

雌蛭木的芽

Kandelia candel
(Linn.) Druce

生長在厭氣中，從水裡冒出雌蛭木的芽。

The Buds of the Kandelia Candel The Kandelia candel grows in brackish water and is shown here with its buds lifting their heads out of the water.

描繪科學化 ●Drawing Scientifically

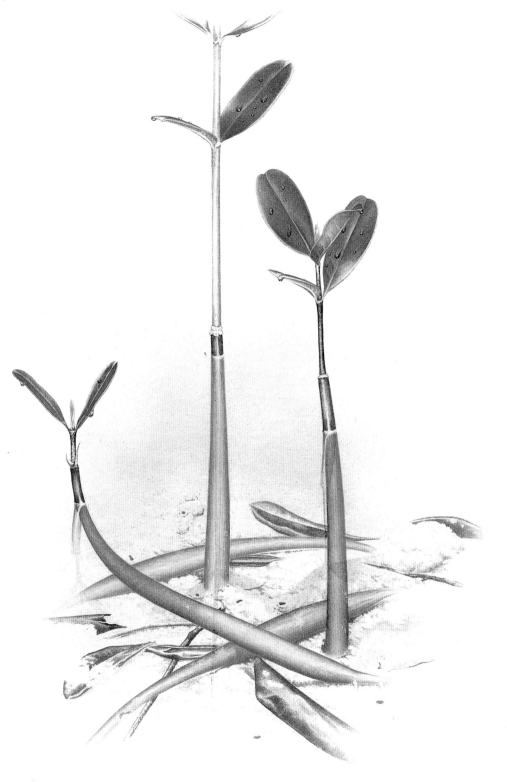

雌蛭木的整體樹形
A View of the Complete Kandelia Candel

地面上的枝頭可看到地面下的胎生種子

Viviparous seeds can be seen on the tips of the branches under the mud.

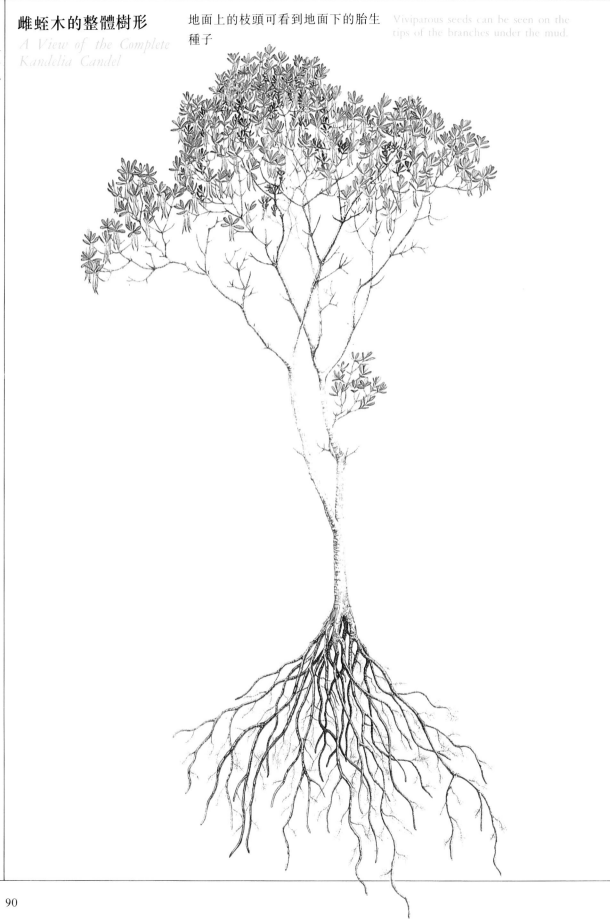

雌蛭木的側面
*A Cross-section of
a Kandelia Candel*

樹皮和樹木的側面，根的側面

A cross-section of the bark and tree.
A cross-section of the roots.

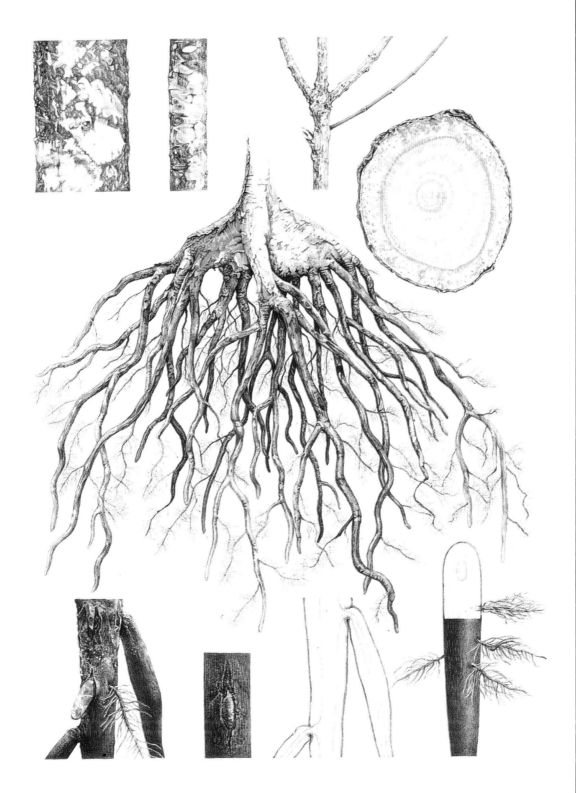

第七章 | 在大自然中繪畫

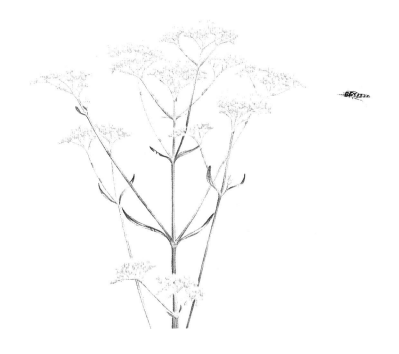

我們已經試著畫了些充滿大自然間原野花香鳥語氣息的
植物素描，高的花兒無法在地面上表現出來，藉著觀察周圍
植物及訪花昆蟲，即可以表現出它在大自然下的生活環境。

Here I have produced some sketches of plants in which I have tried to
add a breath of nature. With tall flowers it is impossible to show the
ground, but by depicting the surrounding plants and the insects that visit
them, it is possible to give an impression of the environment in which they
live.

節分草
Eranthis Pinnatifida

早春林地上開著節分草，等了一天
沒有訪花昆蟲。

The Eranthis pinnatifida blooms on the
forest floor in early spring. Although
I waited all day, not one insect came
to visit the flower.

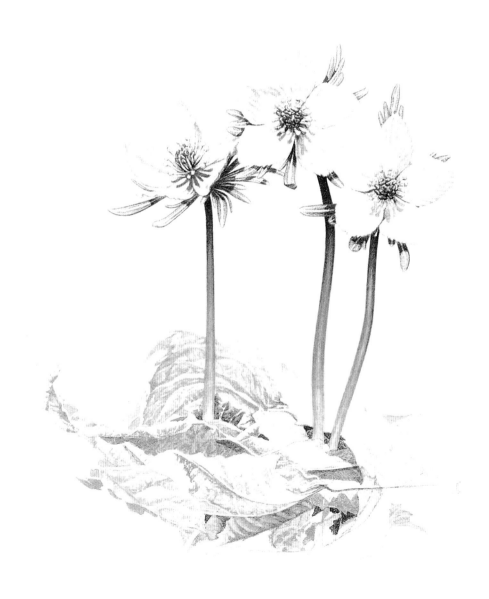

側金盞花
Adonis Amurensis

春日裡開著閃閃發光的側金盞花，
一般認為訪花昆蟲為馬蠅類，等了
一天沒等到。

The Adonis amurensis has golden
flowers that seem to sparkle in the
spring sunlight. It is said that
horseflies (tabanus) come to the
flowers but none appeared during the
course of a whole day.

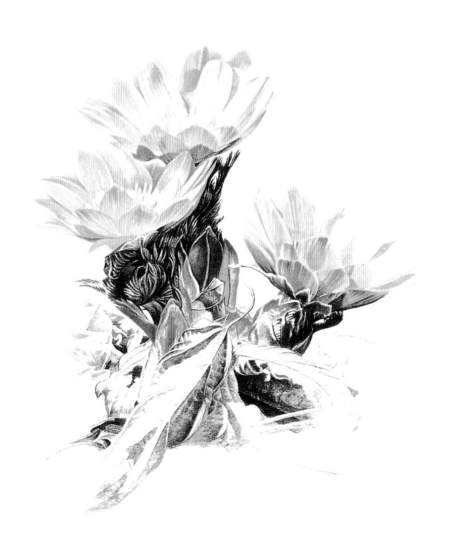

四手辛夷
Magnolia Stellata

為野生種，稀有植物但常被當作庭園木，原產地的訪花昆蟲為日本蜜蜂。

Although this plant is very rare in the wild, it is a common site in gardens. In its natural state, its pollinator is the Apis Cerana japonica bee.

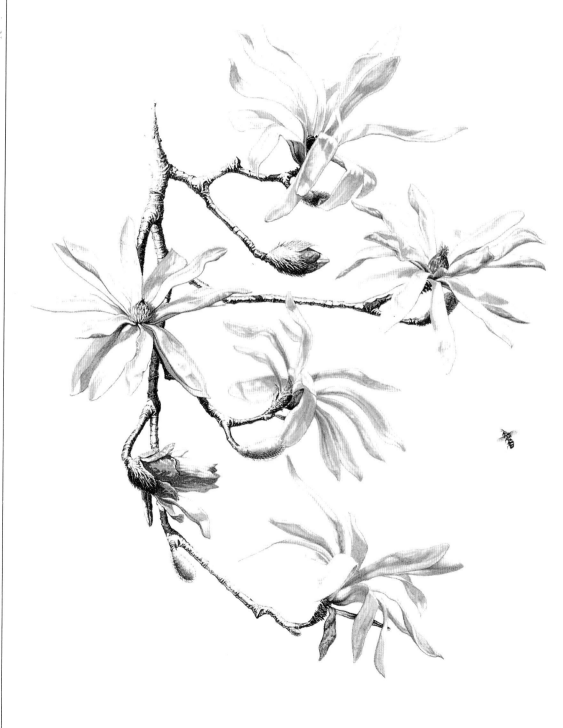

鵝毛玉鳳花
Habenaria Radiata

開在濕地上，地面上和泥炭蘚，茅草，地榆等長在一起，訪花昆蟲是和黃昏一起來的小麻雀。

The Habenaria radiata grows in wetland areas and can be found growing with Sphagnum moss, Imperata Cylindrica, Sanguisorba officinalis etc. Its pollinator is the Theretra japonica moth which comes out at dusk.

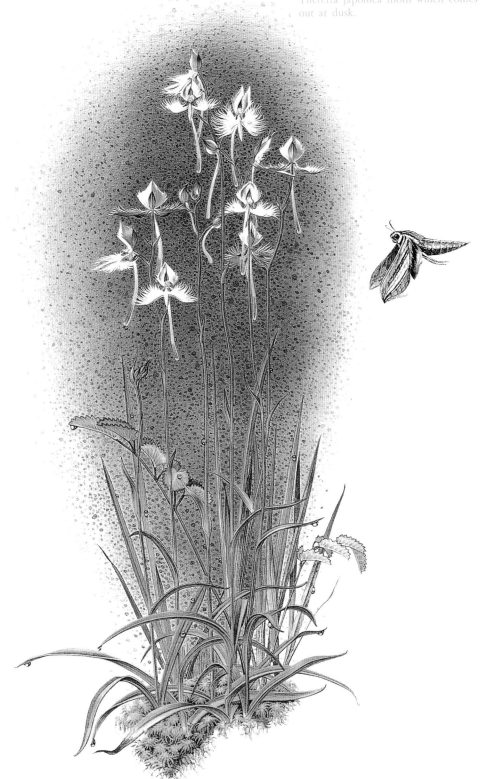

第八章 製作本畫的素描

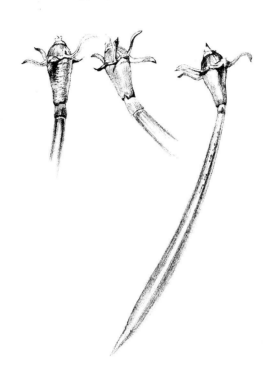

為要正確的描繪植物，清楚的明白目標物的細微處，有必要瞭解整體的樣子，藉眼睛觀察用手上的鉛筆或畫筆將之描繪下來，對目標物的理解度更清楚，照片無法使人清楚地理解花柄和葉子重疊及整體感，即使是很短的時間，實地素描是不可缺少的，建議大家帶些採集物回家做更詳細的素描練習。

The more accurate you try to become, the more important it is to have a firm grasp of the details and overall shape of the subject. Your understanding of the subject will be deepened through observation then drawing or painting of it. The way in which the leaves overlie the stem and the feeling of depth cannot be fully understood through the study of photographs. Even though you do not have the time to stay long, it is vital to visit the spot where the subject grows and make sketches. I also recommend that you collect samples to take home and work on detailed sketches later.

名家・創意系列❸
海報設計
REPUTED CREATIVE POSTER DESIGN

名家・創意系列❷
包裝設計
RERUTED CREATIVE PACKAGE DESIGN

名家・創意系列❶
識別設計
REPUTED CREATIVE IDENTIFICATION DESIGN

CREATIVE

一次
購買三本書
另享優惠

名家序文摘要

名家創意識別設計

陳木村先生（中華民國形象研究發展協會理事長）
這是一本用不同于手法編排，真正屬於CI的書，可以感受到此書能讓讀者
用不同的立場，不同的方向去了解 CI 的內涵。

名家創意包裝設計

陳永基先生（陳永基設計工作室負責人）
「消費者第一次是買你的包裝，第二次才是買你的產品」，所以現階段
行銷策略、廣告以至包裝設計，就成為決定買賣勝負的關鍵。

名家創意海報設計

柯鴻圖先生（台灣印象海報設計聯誼會會長）
國內出版商願意陸續編輯推廣，闡揚本土化作品，提昇海報的設計地
位，個人自是樂觀其成，並予高度肯定。

名家創意
識別 包裝 海報 設計

北星圖書
新形象
震憾出版

名家・創意系列 ❶
識別設計
——識別設計案例約140件
◎編輯部　編譯　◎定價：**1200元**

　　此書以不同的手法編排，更是實際、客觀的行動
與立場規劃完成的CI書，使初學者、抑或是企業、執
行者、設計師等，能以不同的立場，不同的方向去了
解CI的內涵；也才有助於CI的導入，更有助於企業產
生導入CI的功能。

名家・創意系列 ❷
包裝設計
——包裝案例作品約200件
◎編輯部　編譯　◎定價800元

　　就包裝設計而言，它是產品的代言人，所以成功
的包裝設計，在外觀上除了可以吸引消費者引起購買
慾望外，還可以立即產生購買的反應；本書中的包裝
設計作品都符合了上述的要點，經由長期建立的形象
和個性對產品賦予了新的生命。

名家・創意系列 ❸
海報設計
——海報設計作品約200幅
◎編輯部　編譯　◎定價：800元

　　在邁入已開發國家之林，「台灣形象」給外人的
感覺卻是不佳的，經由一系列的「台灣形象」海報設
計，陸續出現於歐美各諸國中，為台灣掙得了不少的
形象，也開啟了台灣海報設計新紀元。全書分理論篇
與海報設計精選，包括社會海報、商業海報、公益海
報、藝文海報等，實為近年來台灣海報設計發展的代
表。

北星信譽推薦・必備教學好書

日本美術學員的最佳教材

INTRODUCTION TO PENCIL TECHNIQUES
鉛筆畫技法

INTRODUCTION TO PASTEL DRAWING
粉彩筆畫技法

INTRODUCTION TO DRAWING WITH PEN & COLOR INK
沾水筆・彩色墨水技法

INTRODUCTION TO BOTANICAL ART TECHNIQUES
野外寫生技法

INTRODUCTION TO EXPRESSING TEXTURES IN OIL PAINTING
油畫質感表現技法

定價／350元　　定價／450元　　定價／450元　　定價／400元　　定價／450元

循序漸進的藝術學園；美術繪畫叢書

實用繪畫範本

粉彩畫技法

油畫基礎畫法

水彩技法圖解

定價／450元　　定價／450元　　定價／450元　　定價／450元

最佳工具書

・本書內容有標準大綱編字、基礎素
描構成、作品參考等三大類；並可
銜接平面設計課程，是從事美術、
設計類科學生最佳的工具書。
編著／葉田園　　定價／350元

精緻手繪POP叢書目錄

### 精緻手繪POP 廣告	### 精緻手繪POP變體字
精緻手繪POP叢書① 簡仁吉 編著	精緻手繪POP叢書⑦ 簡仁吉・簡志哲編著
●專為初學者設計之基礎書 ●定價400元	●實例示範POP變體字，實用的工具書 ●定價400元
### 精緻手繪POP	### 精緻創意POP字體
精緻手繪POP叢書② 簡仁吉 編著	精緻手繪POP叢書⑧ 簡仁吉・簡志哲編著
●製作POP的最佳參考，提供精緻的海報製作範例 ●定價400元	●多種技巧的創意POP字體實例示範 ●定價400元
### 精緻手繪POP字體	### 精緻創意POP插圖
精緻手繪POP叢書③ 簡仁吉 編著	精緻手繪POP叢書⑨ 簡仁吉・吳銘書編著
●最佳POP字體的工具書，讓您的POP字體呈多樣化 ●定價400元	●各種技法綜合運用，必備的工具書 ●定價400元
### 精緻手繪POP海報	### 精緻手繪POP節慶篇
精緻手繪POP叢書④ 簡仁吉 編著	精緻手繪POP叢書⑩ 簡仁吉・林東海編著
●實例示範多種技巧的校園海報及商業海定 ●定價400元	●各季節之節慶海報實際範例及賣場規劃 ●定價400元
### 精緻手繪POP展示	### 精緻手繪POP個性字
精緻手繪POP叢書⑤ 簡仁吉 編著	精緻手繪POP叢書⑪ 簡仁吉・張麗琦編著
●各種賣場POP企劃及賣景佈置 ●定價400元	●個性字書寫技法解說及實例示範 ●定價400元
### 精緻手繪POP應用	### 精緻手繪POP校園篇
精緻手繪POP叢書⑥ 簡仁吉 編著	精緻手繪POP叢書⑫ 林東海・張麗琦編著
●介紹各種場合POP的實際應用 ●定價400元	●改變學校形象，建立校園特色的最佳範本 ●定價400元

野生植物畫法
—描繪山慈姑—

定價：400元

出 版 者：新形象出版事業有限公司

負 責 人：陳偉賢

地　　址：台北縣中和市中和路322號8Ｆ之1

門　　市：北星圖書事業股份有限公司

　　　　　永和市中正路498號

電　　話：9229000（代表）　ＦＡＸ：9229041

原　　著：赤 勘兵衛

編 譯 者：新形象出版公司編輯部

發 行 人：顏義勇

總 策 劃：陳偉昭

文字編輯：劉育倩

總 代 理：北星圖書事業股份有限公司

地　　址：台北縣永和市中正路462號5F

電　　話：9229000（代表）　ＦＡＸ：9229041

郵　　撥：0544500-7北星圖書帳戶

印 刷 所：皇甫彩藝印刷股份有限公司

行政院新聞局出版事業登記證／局版台業字第3928號
經濟部公司執／76建三辛字第21473號

西元1997.2月　　　　　　　第一版第一刷

國家圖書館出版品預行編目資料

野生植物畫法：描繪山慈菇：Introduetion
to botanical art techniques／赤勘兵衛原
著；新形象出版公司編輯部編譯. —第一版
. —臺北縣中和市：新形象，民86
　　面；　　公分
ISBN 957-9679-09-6(精裝)

1.繪畫—西洋

947.3　　　　　　　　　　　85014301

北星文化事業(股)公司

新北市 永和區中正路
456號B1
TEL.(02)2922-9000
FAX.(02)2922-9041
郵政帳號：50042987

書號：　　00008A49
書名：技法4-野生植物畫法
作者：赤　勘兵衞
定價：400.0　　　元整

書局：聯合發行股份有限公司
　　　02-29133656
電話：00008APW0P0